ce
)D

Magic Lantern Guides

PENTAX™
K100D/
K110D

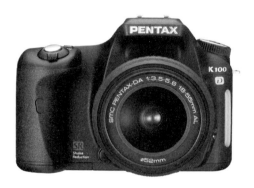

LARK BOOKS
A Division of Sterling Publishing Co., Inc.
New York

Editor: Haley Pritchard
Book Design and Layout: Michael Robertson
Cover Designer: Thom Gaines
Editorial Assistance: Delores Gosnell and Dawn Dillingham
Associate Art Director: Lance Wille

Library of Congress Cataloging-in-Publication Data

10 9 8 7 6 5 4 3 2

Published by Lark Books, A Division of
Sterling Publishing Co., Inc.
387 Park Avenue South, New York, N.Y. 10016

Distributed in Canada by Sterling Publishing,
c/o Canadian Manda Group, 165 Dufferin Street
Toronto, Ontario, Canada M6K 3H6

Distributed in the United Kingdom by GMC Distribution Services,
Castle Place, 166 High Street, Lewes, East Sussex, England BN7 1XU

Distributed in Australia by Capricorn Link (Australia) Pty Ltd.,
P.O. Box 704, Windsor, NSW 2756 Australia

If you have questions or comments about this book, please contact:
Lark Books
67 Broadway
Asheville, NC 28801
(828) 253-0467

Printed in the United States

ISBN 13: 978-1-60059-086-3
ISBN 10: 1-60059-086-1

For information about custom editions, special sales, premium and corporate purchases, please
contact Sterling Special Sales Department at 800-805-5489 or specialsales@sterlingpub.com.

Contents

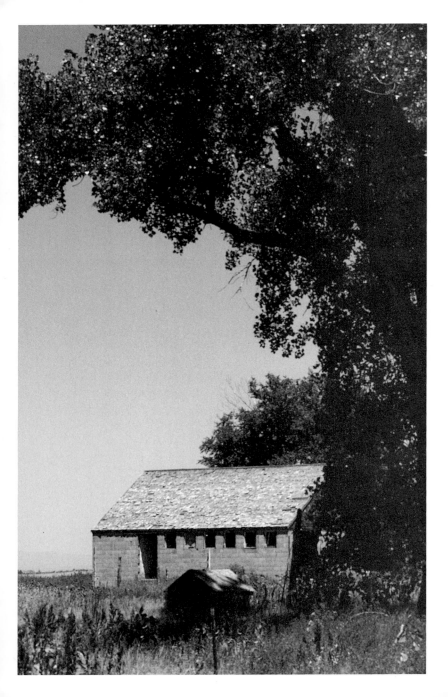

Introduction

Most people don't know that the Asahiflex I, introduced in 1952 by Asahi Optical Company, was the first Japanese-made 35mm single-lens-reflex (SLR) camera. It featured a cloth focal plane shutter, which operated at shutter speeds of 1/20 sec. to 1/500 sec., and bulb. In 1957 Asahi introduced an SLR camera called "Pentax," which was short for PENTAprism reflex. Because the model was so successful, they began branding all of their cameras under the Pentax name.

Another milestone occurred in 1976 with the launch of the legendary Pentax K1000, a camera that introduced millions of people to the joys of SLR photography. This simple, rugged camera with a horizontal, cloth shutter and match-needle exposure control, became one of the most popular SLR cameras of all time.

Pentax celebrated the 30th anniversary of the K1000 with the introduction of the K100D and K110D digital SLRs (D-SLR). The new Pentax K100D is a full-featured, 6.1 megapixel D-SLR with a 2.5 inch (6.35 cm) LCD monitor and Shake Reduction. The K110D is an entry-level digital SLR camera that has all of the features of the K100D, except Shake Reduction. Both models carry the "K" model number, which means they are compatible with Pentax's popular K-mount lenses.

♢ *Pentax, one of the oldest and most respected names in photography, has joined the short list of innovative contenders in the digital SLR category with their latest release of the high-quality K100D series cameras.*

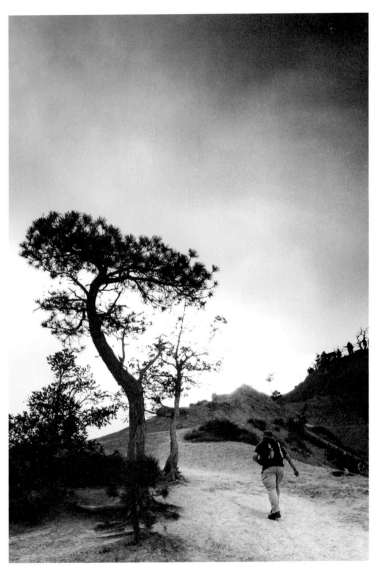

In this homage to W. Eugene Smith's "Walk To Paradise Garden" a lone hiker walks along the rim of Bryce Canyon. The photograph was made with a Pentax K100D and 12-24mm Pentax zoom lens set at 24mm.

The Pentax K bayonet lens mount was introduced in 1975 and all K-mount lenses function on the K100D or K110D digital SLR. Since the K100D's Shake Reduction feature is built into the camera body, it operates fully with any K-mount lenses, including the older manual focus models.

Conventions Used in this Book

This manual covers the complete operation of both cameras—the K100D and the K110D. Except for those sections of the book about Shake Reduction, everything applies equally to both K110D and K100D models. In most cases, to simplify things, I will refer to both cameras as the K100D-series. However, if I mention a specific model (such as the K100D in the section on Shake Reduction), the explanation will only apply to the model that is mentioned.

Unless otherwise stated, when the terms "left" and "right" are used to describe the location of a camera control, it is assumed that the camera is being held in horizontal shooting position.

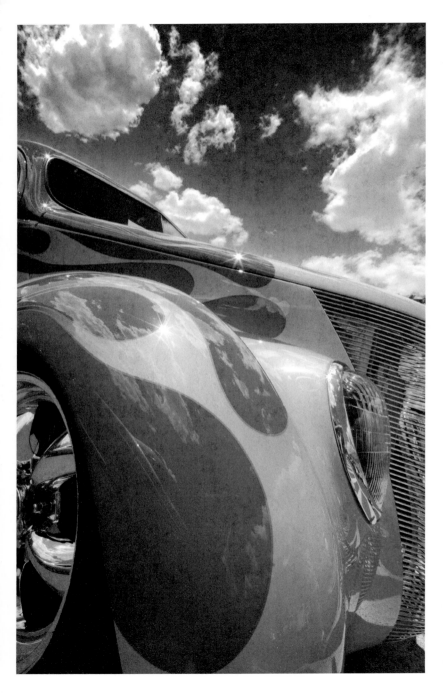

Digital Photography: The Next Level

Only a few years ago, while testing one of the first digital cameras for a magazine, I decided to take the camera to a model train show. At the time, many people asked if I was using a video camera, because they had never seen a digital still camera. This year at that same show, almost everyone was using a digital camera, and they were really enjoying taking pictures. Indeed, one thing that has fueled the popularity of digital cameras more than anything else is they are so much fun to use!

Digital photography extends the old metaphor of "tripping the shutter." It provides many ways of making pictures of your favorite people, places, or things by converting them into those colored dots called pixels. Now that digital SLRs, such as the Pentax K110D, cost less than $600 with a zoom lens, many people are able to enjoy this new hobby. What's even better is that these Pentax D-SLRs are compatible with a lens system you may already own. So, you can dust off your old favorite Super-Takumar lenses and make some great digital images with a truly great digital SLR!

This photograph of a hot rod was made with a Pentax K100D set in Aperture Priority mode. Because my first exposure looked a little dark when viewed on the camera's LCD, I added +0.7 stops of exposure compensation.

Differences between Film
and Digital Photography

Not long ago it was easy to tell the difference between photographs taken with a digital camera and a traditional film camera—the digital ones just weren't as good. Nowadays, images made with digital SLRs are equal to, or better than those made using 35mm film. With the Pentax K100D or K110D model you can easily make 8 x 10-inch photographs (A4) or larger that are superior to a print made from a 35mm negative.

The basics of film and digital photography are essentially the same: Light passes though a lens and is focused onto sensitized media. The big difference is that, instead of silver-based film, a silicon chip captures the image and you get to see the results immediately! There's no film to develop and print. After taking images with a digital camera, you can download them onto your computer's hard drive and, with the help of software, enhance them, send them over the Internet, or make enlargements with a photorealistic printer. Getting results so quickly really means that digital cameras have more in common with traditional instant cameras than conventional film-based models. Some video-compatible digital cameras, including the K100D and K110D, even let you show your pictures on any television set that has camcorder input jacks.

Once you've captured an image on the camera's memory card and downloaded it to your computer, you can re-use the Secure Digital (SD) memory card. And, not only is this media reusable, it's also editable. The K110's preview screen lets you take a peek at a photograph immediately after you've taken it. If your subject's eyes are closed, you can erase that photo and re-shoot it on the spot.

While walking along the rim of Bryce Canyon near dusk, my eye ⇨ *was drawn to this tree, which was tenaciously hanging onto the edge of a precipice. I mounted a Pentax DA 12-24mm lens onto my K100D and made a series of images at slightly different focal lengths. I crouched low to place the top of the tree against the storm clouds in the distance.*

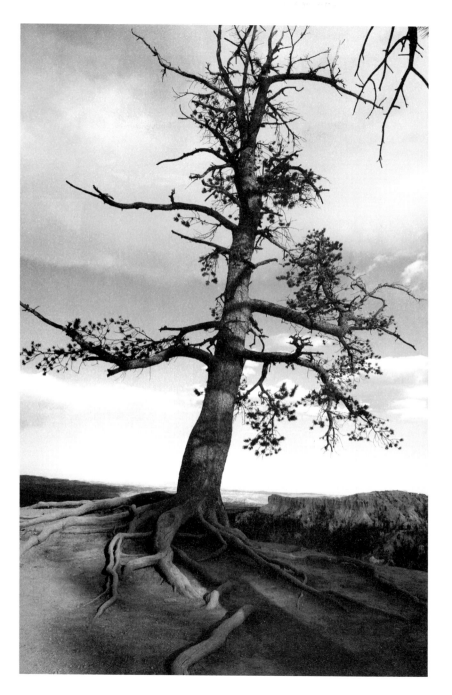

The internal workings of a film SLR and a digital SLR are essentially the same, with the major exception being that, in a digital camera, a sensitized silicon chip captures the image rather than a film strip.

Film vs. Electronics

Film and digital SLRs use a similar technology to expose images. The built-in light metering systems are the same and the sensitivity of both the film and the sensor are based on ISO numbers created by International Standards Organization. The shutter and aperture, which control how much light reaches the sensor or film, are also similar.

Digital still cameras use CCD (Charged Coupled Device) or CMOS (Complimentary Metal Oxide Semiconductor) imaging chips to capture light and convert it into images. As chip design evolves, the quality differences between these two sensor types have diminished and, today, the physical size of the chip is a more important factor in image quality.

Digital sensors respond to light differently than film. A digital sensor responds linearly to the full range of visible

The Pentax K100D series cameras feature a low reflection, 2.5 inch (6.35 cm) thin film transistor (TFT) LCD monitor with histogram display.

light. Film, generally, responds linearly to midtones and is less able to discriminate differences in light intensity in a scene's dark and bright areas. Although film reacts differently to light than a digital sensor, the end result is quite similar, so these days most people can't tell the difference between a digital or film snapshot.

The LCD Monitor

With film, you click the shutter, send the film to the lab, cross your fingers and hope the photographs "come out." With the K100D-series, you can see an image on the camera's 2.5 inch (6.35 cm) LCD monitor right after making the shot. Flash photos can be checked for correct exposure. Although you get to see the photograph immediately, sometimes it may be difficult to judge color, contrast, and brightness in the image file from looking at the LCD. That's when the histogram comes in handy.

The Histogram
Whether shooting film or digital, correct exposure is essential. It may be even more critical for digital than film, especially color negative film, because the latitude (the critical exposure range) is greater with color negative film than for other types of film. Slide film has the least latitude, especially on the overexposure side. Most digital sensors respond like print film in the darker areas of the image and like slide film with brighter tones. Overexposure tends to wipe out detail, while underexposure appears to have more latitude, but creates noise or digital "grain." (More on noise and how to get rid of it later.) The true secret of success in all forms of photography is to properly expose the image.

To critically evaluate exposure, you can use the camera's histogram function, which is unique to digital photography and is available with the K100D series cameras. The histogram appears on the LCD screen as a graph showing the range of brightness in a photograph in 256 steps. Zero is on the left size of the graph and represents pure black, 255 is on the far right and represent pure white. The mid-range values are represented in between. For more on the histogram, see page 126.

Film vs. Memory Cards
Memory cards such as the SecureDigital (SD) cards used in the Pentax K100D series cameras store image files. The SD memory card measures .94 x 1.25 x .08 inches (24 x 32 x 2.1 mm), which allows these Pentax SLR cameras to be nicely compact. The SD memory card is the second most popular memory card format for digital imaging. Unlike it's compatible sibling format, the MultiMedia Card (MMC), SecureDigital media has an erasure-prevention switch to keep data safe. When the switch is in the locked position, it will stop you from accidentally over writing, or deleting, stored images.

Secure Digital cards, such as this Lexar Media SD card, are frequently used in many digital devices including: cameras, MP3 players, PDAs, cellular phones, and camcorders. Photo courtesy Lexar Media, Inc.

Memory cards offer many advantages over film, including:

- **More photos**—Standard 35mm film typically comes in 24 or 36-exposure cassettes. Memory cards come in a wide range of sizes and are capable of holding many more exposures than a roll of film. Even a relatively small, inexpensive 128MB card lets you store from 34-117 image files made with a Pentax K100D.

- **Reusable**—Once you've made a film exposure, the emulsion layer is permanently changed and it cannot be reused. With a memory card, you can erase images at any time, removing the ones you don't want and creating space for additional photos. Plus, once images are transferred to your computer, the card can be totally reformatted, so that it becomes a "clean slate" for taking more pictures.

- **Durable**—Memory cards can be removed from the camera at any time (make sure the camera is turned off first!) and passed through the airport X-ray without suffering damage. They are not as susceptible as film to damage from heat and humidity.

- **Flexible ISO speeds**—Unlike most films, which have a fixed ISO (sensitivity rating), digital cameras can be set to record at a number of different ISO speeds (sensitivities). This can be done at any time, changing even from frame to frame, and the card will capture pictures taken with different ISO settings.

- **Small size**—In the space taken up by just a couple of rolls of film, you can store or tote multiple memory cards that will hold hundreds, maybe thousands, of image files.

ISO

ISO is a standard method for quantifying a film's sensitivity to light. Low numbers, such as 50 or 100, represent less sensitivity; higher numbers, such as 400 or 800, indicate that a film is more sensitive. ISO numbers are proportional in their sensitivity to light. As you double or halve the ISO number, you double or halve the amount of light needed for proper exposure. Film with an ISO of 800 is twice as sensitive to light as 400; 800 speed film is half as sensitive to light as 1600.

Digital cameras do not have a true ISO, which is why you'll often see the term "ISO equivalent" tossed around, but camera manufacturers have developed ways to make an imaging sensor behave similarly to the way film responds to light. Changing ISO picture-by-picture is easy with a digital camera, but is not practical with film. The Pentax K100D series cameras offer ISO equivalents of 200, 400, 800, 1600, and 3200.

Noise or Grain

All digital cameras add noise to images. Like film grain, it's worse at high ISOs and it is more noticeable in areas of uniform color, such as skies or shadows. In both film and digital photography, noise or grain is more obvious in areas that are underexposed. Digital sensor noise is also increased with long exposures in low-light conditions, such as night photography.

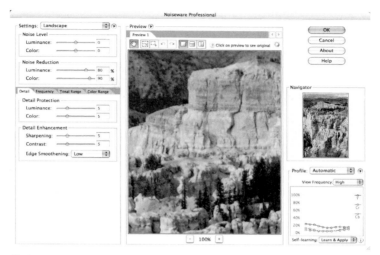

Software such as Imagenomic's Noiseware (www.imagenomic.com) automatically calibrates a noise profile and chooses optimal noise removal settings for each processed image. The latest version allows detected noise levels, as well as noise suppression levels, to be adjusted by tonal and color ranges.

File Formats

A digital camera converts image information from the sensor into 8 or 12-bit color data for each of the three RGB (red, blue, and green) color channels used by K100D series cameras. A bit (binary digit) is the smallest piece of information that a computer uses. Eight bits make up a byte.

When talking about digital image file formats you also should consider a factor called "compression." The K100D-series cameras let you capture images in compressed JPEG or uncompressed RAW format. JPEG (Joint Photographic Experts Group) is an international standard for image compression and is the most common file type used by digital cameras. Data compression enables devices to capture and store the same amount of data using fewer bits. It does this by discarding data that may not be visible to the eye; how well it does this ultimately determines image quality.

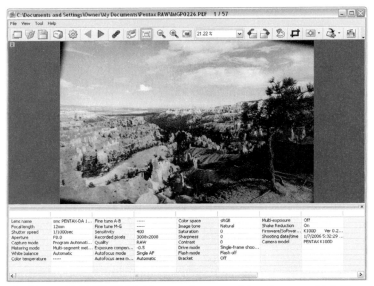

Working with RAW (PEF) files requires special software, which Pentax includes with the camera.

JPEGs compress an image file into discrete blocks of pixels, which are divided in half using ratios that vary from 10:1 to 100:1. Although the higher compression ratio means quality loss, the number of images that will fit on the SD card increases. Lower compression produces better quality images, but they take up more room on the card. Digital cameras use this format, because it reduces the size of the file, allowing more pictures to fit on a memory card. The cameras' highest image quality option is "no compression," with the RAW or PEF (Pentax Electronic Format) format.

Both RAW and JPEG files produce excellent results. When faced with challenging lighting situations, you may find that shooting a RAW file will give you more control. However, for most general shooting, the JPEG file is faster and easier to use both in-camera and later in the computer. Unlike JPEGs that are ready to use out of the camera, RAW files must first be processed using software that Pentax provides with the cameras.

The most important factor in deciding which format will work best for you is your own personal shooting style and digital darkroom workflow. If you want to shoot quickly and spend less time in front of the computer, JPEGs are the best choice. If you loved working in a traditional darkroom, or are familiar with the software and enjoy image processing in the computer, you might prefer RAW files.

Digital Resolution

With film, the word "resolution" refers to the amount of detail that is separate or distinguishable. Resolution in digital imaging is expressed in different ways. In the case of digital cameras, resolution indicates how many individual pixels are contained on the imaging sensor. This is usually expressed in megapixels. Each pixel captures a portion of the total light falling on the sensor and it's from these pixels that the final image is produced. A 6-megapixel camera, such as the K100D, has 6-million pixels covering the sensor. Resolution has a different meaning when it comes to inkjet printing. In this case it is expressed in dots-per-inch (dpi), which defines how many individual dots of ink there are per inch of paper area.

The K100D series cameras offer three different resolution settings (3008 x 2008, 2400 x 1600, and 1536 x 1024.) You don't have to utilize the maximum resolution, but if you want to make the best possible images, it is a good idea to use the highest setting available. This is particularly important when making prints larger than snapshot size. Although, you can always reduce resolution later in the computer, you cannot create higher resolution if you did not capture the data initially. There are a few situations where you might prefer to shoot at a lower resolution than the maximum. When you absolutely know that you will only be using the photo for email or the Internet, lower resolution files will save space and let you store more images on your memory card.

If you want to make a big enlargement, you need to shoot at the camera's maximum resolution. © Mary Farace

To determine how large a print you can make (with acceptable quality) from a given file's resolution just divide each of the pixel dimensions by the linear print resolution of 200 (dpi.) A file recorded at 1536 x 1024 pixels, for example, will produce a 5 x 7 inch (12.7 x 17.7 cm) print. The higher the original shooting resolution, the larger the print you can make.

The Color of Light

While different types of lighting often look the same to our eyes, they usually have different color temperatures, which are measured on the Kelvin scale. The sun on a clear day at noon is about 5500 Kelvin (K). On an overcast day, the color temperature of light rises to 6700K, while 9000K is what you

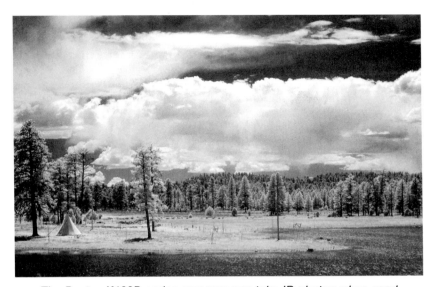

The Pentax K100D series cameras can take IR photos when used with a filter such as Singh Ray's I-Ray, which blocks visible light. This photo was made with a K100D set at ISO 800. The camera was mounted on a tripod to maintain sharpness during the long exposure.

will experience in open shade on a clear day. When we photograph a sunrise, its color temperature may be low on the Kelvin scale—at about 1800K. Tungsten lights used by videographers have a Kelvin temperature of 3200K. Household light bulbs measure about 2600K.

Fluorescent lighting is one of the toughest color film photography challenges. The type and age of the tubes affect color and usually require special filtration to produce an image that looks neutral. Filters may be helpful in correcting the light's color, but they darken the viewfinder and increase exposure time. With digital cameras, everything has changed.

Color correction is managed by the K100D's white balance function, which uses electronics to neutralize whites

and balance colors—without the need for filters. When set in AWB (Auto White Balance) mode, K100D series cameras automatically correct for the light's color. White balance can also be set for specific light conditions, such as: Daylight, Shade, Cloudy, Tungsten, Fluorescent, and Flash. There is also an option for manual white balance.

Invisible Light
Every photographer knows about the visible light that's used to capture photographic images with film or digital media, but there are also wavelengths that we can't see. Wavelengths ranging from 700 and 900 nm (nanometers) are called infrared light. This band of infrared light is a thousand times wider than that of visible light. Some cameras, like the Pentax K100D series, are capable of infrared photography when an appropriate filter is placed in front of the lens.

Cost of Shooting

After you've paid for the camera and memory card, there is little or no cost in shooting a large number of photos with cameras such as the Pentax 100D.

There is no such thing as "wasting film" since we can reuse a camera's memory card over and over again. This freedom can be liberating, allowing photographers to experiment with exposure, composition, and camera angles. Any shots that don't work out can simply be dropped into the digital "trash can" and the space on the card can be reused.

With a digital camera you can change the ISO as needed and check the results in the LCD monitor. © M. Morgan ⇨

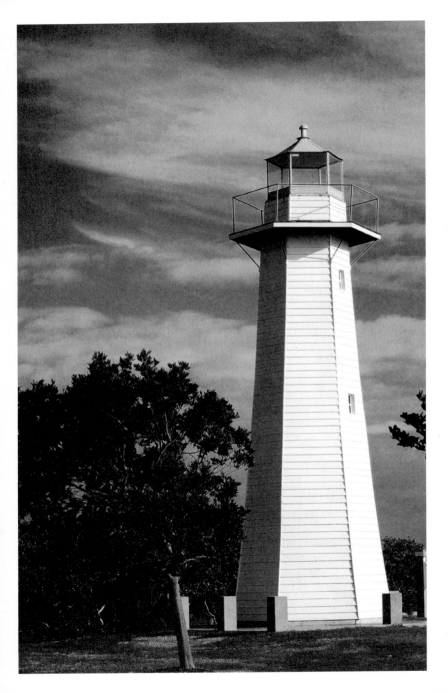

Features and Functions

The digital SLR represents the future of photography. The upgrade for today's amateur photographers, who want more than a point-and-shoot offers, is a low to medium priced digital SLR, such as the Pentax K100D-series cameras. These relatively inexpensive, very capable cameras are small, easy to use, produce high-quality pictures, and accept an extensive system of lenses.

With 6.1 effective megapixel resolution, the Pentax K100D digital SLR and its sibling the K110D, are a good choice for a beginning digital SLR shooter. Or, if you own a Pentax film SLR camera with K-mount Pentax autofocus or manual focus lenses, these cameras are a great way to update your system and "go digital."

The Pentax K100D-series SLRs are digital still cameras with through-the-lens (TTL) autofocus, auto exposure, and a built-in flash. Both models accept all K-mount optics including Pentax KAF2, KAF, and KA mount lenses.

The Shake Reduction (SR) system that's offered in the K100D makes it possible to capture sharp, blur-free images even in difficult shooting conditions, such as telephoto photography in low existing light. The SR mechanism is designed to minimize camera shake by using magnetic force to move the CCD image sensor vertically and horizontally at high speeds, while adjusting the speed of oscillation in proportion to the amount of shake detected by a sensor built-into the camera body. All of this technology is wrapped up in a high-rigidity, stainless-steel chassis covered by a compact lightweight fiber reinforced polycarbonate body.

This Australian lighthouse was photographed using a Pentax K100D camera in Manual exposure mode. © Hisashi Tatamiya

The Pentax K100D has a built-in Shake Reduction (SR) system. This innovative design does not require special, expensive, anti-shake optics; it can be used with almost all existing Pentax-mount interchangeable lenses.

Specifications

- 6.31 megapixel CCD image sensor, 23.5 x 15.7 mm
- Pentamirror with Natural-Bright-Matte II focusing screen
- 96% Viewfinder Coverage
- 2.5-inch (Low Reflection) TFT color LCD monitor, with histogram display, LCD coverage - 100%, angle of view—approximately 140 degrees
- Continuous shooting at 2.8 frames per second (fps), up to 5 JPEG, 3 RAW
- High speed USB 2.0 interface, Video output is compatible with NTSC and PAL formats
- TTL phase-matching 11-point autofocus system (SAFOX VIII) w/AF assist lamp
- TTL open-aperture metering with choice of: 16-segment, center-weighted, or spot meter
- High-speed shutter, up to 1/4000 sec. with flash synch to 1/180 sec.
- Shake Reduction — CCD image sensor shift type—built into the K100D body
- Compatible with all Pentax K-Mount lenses made since 1975
- Powered by 4-AA (lithium, alkaline, and rechargeable NiMH) batteries, or 2-CR-V3 lithium batteries; an AC adapter is optional

Pentax K100D – Front View

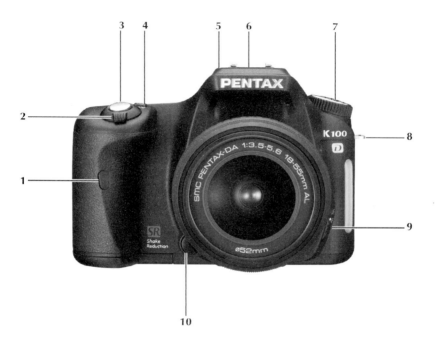

1. Self-timer lamp ⟳ /
 Remote control receiver ▮
2. Main switch
3. Shutter release button
4. Av button ⊠ Av
5. Built-in flash

6. Hot shoe
7. Mode dial
8. Strap lug
9. Focus mode lever
10. Lens unlock button

Pentax K100D – Rear View

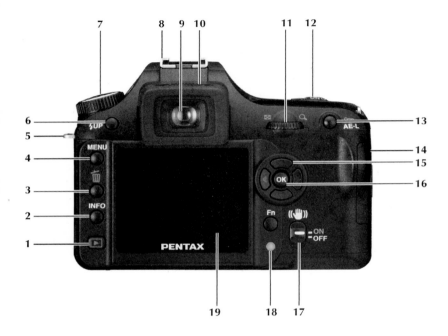

1. Playback button ▶
2. INFO button
3. Delete button 🗑
4. MENU button
5. Strap lug
6. Built-in flash button ⚡UP
7. Mode dial
8. Hot shoe
9. Viewfinder
10. Diopter adjustment lever
11. e-dial
12. Main switch
13. Autoexposure lock button AE-L/o⌐
14. Card cover
15. Four-way controller
16. OK button
17. Shake Reduction switch (((📷)))
18. Function button Fn
19. LCD monitor

Pentax K100D – Top View

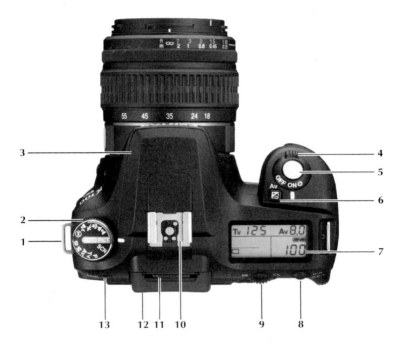

1. Strap lug
2. Mode dial
3. Built-in flash
4. Main switch
5. Shutter release button
6. Av button ⊞Av
7. LCD panel
8. Autoexposure lock button
 AE-L/○₋ₙ
9. e-dial
10. Hot shoe
11. Diopter adjustment lever
12. Viewfinder
13. Built-in flash button ⚡UP

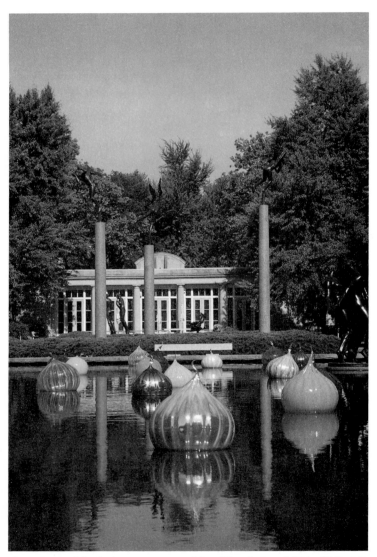

A custom white balance was used for this photo of Dale Chihuly's "Glass in the Garden" exhibit at the Missouri Botanical Garden. The camera's four-way controller allows you to quickly and easily change camera settings, so that you can keep on shooting. © M. Morgan

Overview of Controls

It is helpful to have your camera with you while you read this overview of K100D-series controls.

The Pentax K100D-series cameras uses icons, buttons, and dials. The K100D -series camera's main controls, which manage the most often used functions, are the Mode dial and four-way controller.

Camera Activation
The main (power) switch is on the right, top of the camera surrounding the shutter release button. It features a clock-wise rotating collar that has three positions: OFF, ON, and Depth-of-Field Preview ↻ , which allows you to check an image's depth-of field while holding the main switch.

The main switch has three positions including Depth-of-Field Preview, which is indicated by ↻ .

Auto Power Off
To preserve battery life, all digital cameras have some type of "auto-off" feature that shuts the camera down, after a specified period of inactivity. The default time is one minute, but you can change it by going to the Set-up menu and scrolling down (with the four-way controller) to the [Auto Power Off] setting. Selections are available for one, three, five, ten, or thirty minutes, and OFF. Use the right button of the four-way controller to select one of the options, then scroll down using the down button to highlight your choice. Click the OK button to store the setting.

Why should you take the time to do this? Because the setting you select may cause the camera to power down at a time when it is not convenient. When you try to shoot, nothing will happen! If the camera auto powers off when you're getting ready to photograph little Billy taking his first steps, you could miss an important shot while the camera is powering up. I keep my K100D set at ten minutes—you should pick what works for you and your style of photography.

The Pentax K100D series cameras have a Mode dial with different shooting modes, as well as Scene Modes for specific subjects like sports or portraits.

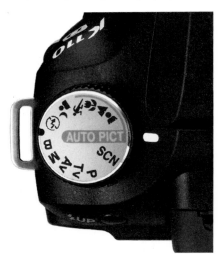

Mode Dial

Located on the left top of the K100D series camera, the mode dial is used to select any of the standard auto exposure modes (P, Tv, Av, M, and B) as well as six subject related Picture Modes; this includes Auto Pict—the green zone that automatically selects Normal, Portrait, Landscape, Macro, and Moving Object modes.

Four-Way Controller

The four-way controller is located on the back of the camera to the right of the LCD monitor. It functions differently depending on the mode in use:

In capture mode it allows you to access needed controls that often require adjustment like: drive dode, ISO, white balance, and flash. These functions are accessed by first depressing the **Fn** button on the lower right camera back, below the four-way controller. The four buttons, or keys let you move the cursor up, down, left, or right to change items in any of the camera's menus.

In playback mode you can use these buttons to review previously captured photographs, moving back and forth between all of the images stored on the memory card.

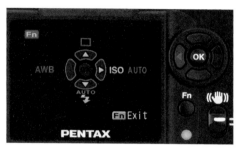

The Pentax K100D series' four-way controller provides quick access to frequently used controls like ISO, white balance, and flash. It's useful in playback mode for scrolling pictures back and forth on the LCD monitor.

Shutter Button

The K100D series features an electromagnetic shutter release, located on the right top of the camera above the handgrip. Pushing it down halfway (position 1) activates the camera's autofocus system. Depressing it fully (click) releases the shutter and exposes the sensor. The viewfinder indicators remain on while the shutter release button is partially depressed and stay on ten seconds after an exposure has been made. To minimize camera shake, you should gently press the shutter release when making a photograph; even though the K100D has Shake Reduction, careful release of the shutter with either model will maximize image sharpness. Practice until you are used to the feel of partially depressing the shutter button and then completing an exposure. The best thing about a digital camera is that you don't burn any film while practicing, so go for it!

E-Dial

The e-dial is located on the upper right back of the camera, directly above the four-way controller. It is a horizontal wheel designed to allow the thumb to move it to make changes. Depending on what mode you are in, the e-dial lets you set shutter speed, aperture, and EV compensation. In Shutter Priority (Tv) mode, turn the e-dial to adjust the shutter speed. In Aperture Priority (Av) mode, turn the e-dial to adjust the lens aperture (f/stop) with lenses that don't have aperture dials. In Manual (M) mode, turn the e-dial to adjust the shutter speed. To set the aperture, press the **⊠Av** button (on the right top of the camera, behind and left of the shutter release), then turn the e-dial to adjust the aperture. To adjust exposure compensation in Program (P) mode, turn the e-dial while pressing the **⊠Av** button. In playback mode, you can rotate the e-dial to magnify the image on the screen in increments up to 12X.

Menus Overview

The Pentax K100D series cameras have several menus for functions involved in shooting, viewing, or enhancing images. When you depress the MENU button, located on the camera's back to the left of the LCD screen, menus are dis-

In capture mode, when you press the MENU button, you'll see a display offering four tabbed sections that provide control over many aspects of the Pentax K100D series cameras' operation.

For general photography, like this shot of a Jaguar XJ-S, I keep the [Auto Power Off] setting at ten minutes because I'll usually make another exposure within that timeframe.

played on the 2.5-inch (6.35 cm) color LCD. The menu structure consists of four tabbed sections: Rec Mode, Playback, Set-Up, and Custom Settings. You can navigate horizontally or vertically using the four-way controller.

Resetting Controls

With so many adjustable functions on your Pentax K100D series camera, there might be a time when you have forgotten what you have set and why. That's a good time to use the reset function to return the camera to its factory default settings. Press the MENU button and go to the third tab—

Set-Up. Use the down button in the four-way controller to scroll to the last item in this menu—[RESET]. Click the OK button and the camera will go back to most of its default settings. Some things that you probably don't want to change, such as [Date Adjust], [Language], and [Time], will not be reset.

The Viewfinder

Pentax K100D series cameras feature a pentamirror with a non-interchangeable Natural-Bright-Matte II focusing screen. Images from the lens are reflected into the viewfinder by a mirror that lifts during exposure, then quickly returns to minimize SLR "viewing blackout." The viewfinder shows 96% of the actual image captured by the sensor and produces 0.85x magnification, when used with a Pentax 50mm f/1.4 lens—a great lens for available light portraits.

A camera's eyepoint refers to how far away from the eyepiece you can position your eye and still see the entire viewfinder image; that's important to people, like me, who wear eyeglasses. The "official measurement" of the Pentax K100D series' eyepoint is 21.5mm, which is the distance from the finder cover to the photographer's eye. (The actual distance from the viewfinder lens to the eye is a bit longer, but there is no industry standard on how eyepoint is supposed to be measured.)

The viewfinder display includes information about the camera's settings, although not all of them appear at the same time. The camera's 11 autofocus (AF) points appear on the focusing screen and a solid band at the bottom shows exposure information, frame number, picture mode icons, and sensitivity warning. An ISO sensitivity warning appears in the viewfinder when the set sensitivity is exceeded. A Custom Setting allows you to turn this warning off, or turn it on, when your choice of ISO 400, 8000, 1600, or 3200 is set. I turn it off.

Pentax K100D Series – Viewfinder

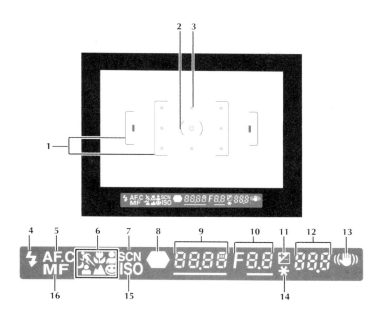

1. AF frame
2. Spot metering frame
3. AF point
4. Flash status
5. Continuous focus (Continuous focus mode) mode
6. Picture mode icon
7. Scene mode icon
8. Focus indicator
9. Shutter speed/ Confirm sensitivity
10. Aperture value
11. EV compensation
12. Number of recordable images/EV compensation
13. Shake reduction display
14. AE lock indicator
15. ISO sensitivity warning
16. Manual focus

Viewfinder Adjustment

The K100D series cameras have built-in diopter correction in the viewfinder and, depending on your prescription, you may not need to wear glasses while shooting; adjustments vary from 2.5m to +1.5m. You can fine-tune it by moving the sliding diopter adjustment lever (just above the rubber eyepiece) back and forth. The best way to set it is to look at the viewfinder display information not the scene in the viewfinder, and move the slider until sharp..

Hint: A rubber eyecup is standard equipment on K100D series cameras. You may find that it is easier to adjust the diopter setting if you remove the eyecup. Do this by pulling it out on its right side. To reattach it, simply snap it back on.

The LCD Monitor

The LCD preview screen on digital SLRs is one of the best features the digital camera has brought to the art and craft of photography. The K100D's large 2.5 inch (63.5 mm) LCD monitor has 210,000 pixel resolution, a wide viewing angle, and 12x zoom. The screen shows 100% of the captured image and the large screen size and excellent contrast make it useful for evaluating captured images.

You can adjust the LCD screen brightness in 14 steps (plus or minus seven levels from nominal), to find a level that offers the best view. Pressing the right button on the four-way controller makes a sliding scale appear. One of seven positive or negative settings can be selected using the left and right buttons.

Hint: Don't over-brighten the screen because it shortens battery life.

The K100D's LCD screen can also display a histogram—a graphical representation of a photograph's exposure values from the darkest shadows (on the left side) to the brightest highlights (on the right side.) Pressing the Playback button

PENTAX

The 2.5 inch (6.35 cm) LCD monitor on the Pentax K100D series camera is an excellent tool for evaluating and editing your images immediately after exposure. The buttons to the left of the monitor control numerous functions, including menu display, image deletion, exposure data, and playback.

▶ on the left of the LCD screen and then the INFO button (just above it) will superimpose a histogram on the image. The ability to see the recorded image at the same time as this exposure graph lets you evaluate the image that was captured by the sensor and consider what corrections may be needed.

The histogram's horizontal axis indicates the level of brightness, while the vertical axis indicates the pixel quantity for the different levels of brightness. If the graph rises as a slope from the bottom left corner of the histogram, then descends towards the bottom right corner, all the tones in the image should br captured. If the graph starts out too far in from either side of the histogram, so that the slope appears cut off, then the photograph is missing data from those areas; the image's contrast range may be beyond the camera's capabilities. When the his-

togram is weighted towards either the dark or bright side of the graph, detail may be lost in the thinner of the two areas. When highlights are important, be sure that the slope on the right reaches the bottom of the graph before hitting the right side.

Hint: Don't be a slave to a "perfect" histogram. While the classic histogram features a bell-shaped curve, not every photograph you'll make will fit this distribution of values. A high or low-key creative image will have a lopsided histogram. Does that mean that exposure correction is needed? Not necessarily; the histogram may be appropriate for subject or the creative look that you want.

You can also use the e-dial to magnify a portion of an image on the LCD up to 12X in 15 steps. The enlarged image is scrollable, using any of the four buttons in the four-way controller. If you want to make sure that all eyes are open in a group photo zoom in and check them.

The LCD Panel

The LCD Panel is located on the right top of the camera, just behind the shutter release. It is always in operation when the camera is turned on and displays camera various settings: shutter speed, aperture, flash information, auto bracketing, and more.

Power

Unlike many other digital SLRs that tie their users down by using a proprietary rechargeable battery system, the Pentax K100D series uses common AA batteries. The camera is packaged with AA alkaline batteries for checking the camera's functionality, but they may not support all of the camera's functions under certain conditions. Pentax recommends that you power the camera with two CR-V3, four lithium AA batteries, or four AA rechargeable Ni-MH batteries. Due to their voltage characteristics, oxyride and rechargeable CR-V3 batteries are not recommended, because they can cause the camera to malfunction.

Pentax K100D – LCD Panel

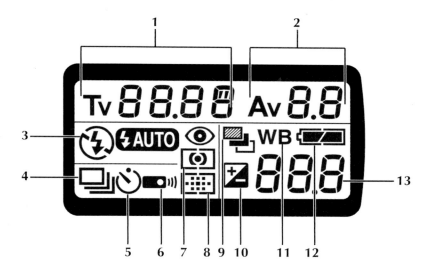

1. Shutter speed
2. Aperture value
3. Flash Information Auto, Flash-On, Flash-Off, and Red-eye reduction.
4. Single frame advance/ Continuous advance
5. Self-timer
6. Remote control
7. Metering Information
8. Focus point indicator
9. Auto bracketing
10. Exposure compensation factor
11. White balance information
12. Battery information
13. Number

When using CR-V3 batteries you can expect to get 850 shots; based on my real-world shooting experience, outdoors without flash, this is a minimum number. When half or more of your shots use the built-in flash, this number drops to around 650. If you use AA lithium batteries, expect to get 750 shots, dropping to around 550 with use of the built-in flash. When using rechargeable Ni-MH AA batteries you can expect to get 560 shots, which decreases to around 440 with use of the built-in flash.

Published ratings are based on CIPA (Camera & Imaging Products Association) standards at 73.4° F (23° C). Variation from these numbers may occur depending on shooting mode and conditions.

When using the camera in cold climates, keep an extra set of batteries warm in your pocket. Battery performance returns to "normal," at room temperature.

Date/Time

Included in the EXIF (Exchangeable Image Format) data that's recorded with an image file is the date and time, so you know exactly when you made a particular image. This is not only helpful when looking at an oler image file, but also many software programs use this date information to help sort, retrieve, and manage all of your image files.

After pressing the MENU button, go to the Set-Up tab, and use the four-way controller to scroll down to [Date Adjust]. The first choice is [Date Style]; use the four-way controller's up or down buttons to scroll through the choices (mm/dd/yy, yy/mm/dd, or dd/mm/yy). Then scroll right to choose either a 12 or 24 hour clock. Next, move down and set the date using the four-way controller's buttons to change the month, day, and year; do the same for setting the time.

The K100D series also has a [World Time] setting for the various time zones. After selecting [World Time] from the Set-up menu, you're presented with maps with pinpoint

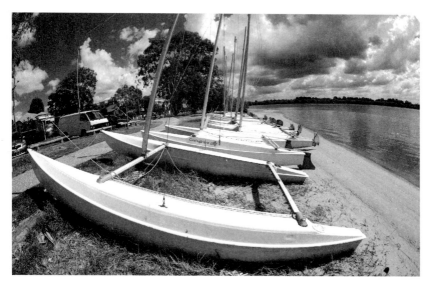

This photograph of sailboats on an Australian beach was made using a Pentax K100D camera with the smc P-DA Fish-Eye 10-17mm F3.5-4.5 ED (IF) lens. © Hisashi Tatamiya

locations. When you find the country you're in, use the down button to find the city. OK, locks it in. While this may seem unnecessary, changing the location while you're on vacation, for example, automatically shifts the EXIF time settings to local time. Otherwise, later on, you may wonder how you took that great sunset at high noon.

The Sensor

The imaging chip used in the Pentax K100D series cameras is an interline interlace CCD with a primary color filter. It has a total pixel count of 6.31 megapixels with a color depth of 8-bit (JPEG) or 12-bit (RAW.) The physical size of the chip is 23.5 x 15.7 mm, often referred to as APS-C. A standard 35mm film frame measures 24x36 mm. When you mount a K-mount lens that was designed for use on a 35mm film camera on a Pentax K100D series camera there is a "magnification factor."

Pentax K100D series cameras have a factor of 1.5. This means a 50mm K-Mount lens mounted on a K100D will have a field of view that is equivalent to a 75mm lens on a 35mm film camera. It's important to realize that the focal length of the lens doesn't change. The difference is that the image in the viewfinder looks like a 50mm shot that was cropped into the angle-of-view of a 75mm lens. If you're a wildlife photographer salivating at the prospect of turning your 400mm lens into a 600mm keep in mind that the moose is still going to be the same size as he might be in the viewfinder of a 35mm film camera, but he will be cropped a bit tighter.

In the camera's Custom Setting menu there's a choice to have [Noise Reduction] turned off or on. When you check ON, the camera's [Noise Reduction] circuitry activates whenever slow shutter speeds are used.

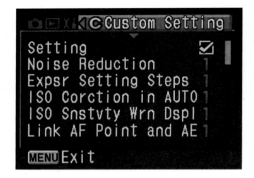

Noise is the digital equivalent of film grain and appears as an irregular, sand-like texture that, if large, can be unsightly. It is more noticeable with high ISO speeds and/or long exposures under low-light conditions. Unlike film, digital sensors are not subject to color reciprocity failure during long exposures, which is a good thing.

Mirror Lock-Up

There are times, such as when shooting in very low light, that even the K100D's Shake Reduction won't be sufficient. That's when you want to drag out that tripod that's been collecting dust in your closet and turn off the camera's Shake Reduction feature. While the camera doesn't have a mirror lock-up feature, you can make your camera act as if it did.

Photographing a sunset is a good time to turn on the K100D's Noise Reduction feature.© Hisashi Tatamiya

Push the **Fn** button and access the camera's [Drive mode] menu using the four-way controller. When pressing the Up button you can choose from several options including the standard (12-second) self-timer or a two-second self-timer, which causes the mirror to lock up as soon as the shutter release is pressed. The image is exposed two seconds later. This will eliminate the vibration caused by the mirror moving up out of the light path when the shutter is tripped.

Shake Reduction

The Pentax K100D—but not the K110D model—incorporates a high-tech feature called Shake Reduction (SR) that helps create sharp, blur-free handheld shots with any Pentax lens. An electromagnetically controlled system that's built into the body detects handheld camera shake and compensates for it by moving a free floating image sensor. This feature is particularly helpful in situations, such as when using telephoto

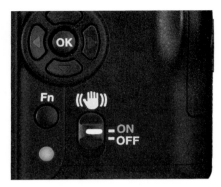

Shake Reduction is activated by an on-off switch located on the lower right rear of the camera, below the four-way controller.

lenses or photographing in low light without flash. As a result, photographers can capture sharp images at a shutter speed that is about two to three and a half stops slower (e.g. 1/15 sec. instead of 1/60 sec. with a standard lens) than would otherwise be possible. The SR system also provides an important advantage when shooting handheld with telephoto focal lengths, in close up photography, or any other situation that may magnify the effect of camera shake. Unlike other optical-based anti-shake systems that are built into the camera's lenses, the SR system is in the camera, making Shake Reduction available with any lens.

Over 30 patents have been filed for the SR system, which uses a ball-bearing-mounted oscillator unit with four electromagnets that hold the free-floating image sensor. Angular velocity sensors detect camera movement and relay the amount of compensation necessary to the electromagnets, which move the sensor to compensate.

Additional Advantages of the PENTAX SR System

- Since the SR system is activated only when you press the shutter release, battery consumption is negligible.
- Pentax SR is optional. You can leave SR on permanently, turning it off only when using a tripod or panning (deliberately moving the camera in the direction of subject motion to blur the background). Using a monopod? Turn it on.
- Performance capabilities such as auto-focus speed, shutter lag time and continuous shooting rate are unaffected by the SR system, because its operation is instantaneous—occurring within the normal exposure interval.
- To provide optimal shake reduction, the camera must "know" the focal length of the lens in use. Pentax F, FA, D-FA, and DA series lenses automatically relay focal length information to the camera.

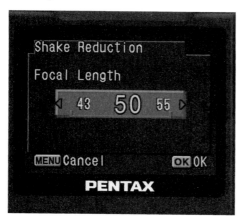

For Shake Reduction to work properly, the camera must be able to process focal length information from the lens. With older Pentax lenses, this information must be manually input via the Shake Reduction menu, which allows focal lengths from 8mm to 800mm to be entered.

Memory Cards

Memory cards such as the SecureDigital (SD) cards used in Pentax K100D series cameras store image files until you're ready to download them to your computer. When the switch on the side of the card is in the locked (down) position, it will prevent accidental deletion of stored data.

To insert a SD card, push the card cover door on the right side of the K100D open by sliding it towards you. Then swing the cover open, exposing the memory card slot. Insert the SD card with the label facing you until it locks in place. Swing the cover door closed and push it forward to lock it.

When inserting a new SD card in a K100D series camera, you can use the camera's menus to set the folder name and file numbering system both of which are accessed through the Set-up menu:

With the [STD] (standard) option, your memory card will contain a folder named "DCIM" which in turn will hold a folder typically called "pentax100" that includes all of your image files. In [DATE] mode, you'll still have the "DCIM" folder, but inside will be a series of folders, named by date, which contain all of the image files recorded on a given date. The date mode is ideal if you know what day an image was taken or if you want to sort photos by date.

The Set-up menu give you two options for file numbering:
- **[SerialNo]** (the default) is the file number of the most recently captured image and remains continuous after inserting a new SD card.
- **[Reset]** sets the file number to the smallest number each time a new SD card is inserted. When an SD card that already has stored images is inserted in the K100D camera, the numbering continues from the last stored file. If you shoot lots of pictures, it probably best to use the [SerialNo] option, because you won't be able produce duplicate file numbers that can cause chaos and confusion later.

Care of Memory Cards

• Never remove a memory card when the card access lamp (that's the unlabeled LED just below the **Fn** button) is lit.

• Don't turn off the camera while it's writing a file to the SD card.

• Don't bend, scratch, or subject a memory card to high heat.

• Keep the cards away from airport metal detectors by putting them in your camera bag, not your shirt pocket.

• Before using a card you should always format it.

When inserting a card, make a habit of pushing the Playback button ▶ to see what images are already on it. If you have not already copied those images to your computer's hard drive or other form of backup media, do not format the card.

Formatting Your Memory Card

Caution: *Formatting erases all of the images and information stored on the memory card, including protected images. Be sure that you have transferred all of the important images to your computer's hard drive before formatting the card.*

Before you use a new SD card in your camera, it must be formatted specifically for the Pentax K100D series. To format your SD card after inserting it, press the four-way controller to go to the Set-Up menu. Press the down button to go to [Format] (it's the first item) and press the right hand button to go to the [Format] screen. You have two choices: [Format] or [Cancel]. The default is [Cancel] so use the up button on the four-way controller to select [Format] and press the OK button.

It's a good idea to reformat your SD card in the camera each time you download images to the computer. This "cleans up" the card and keep its data structure organized. Remember, once you reformat, everything will be gone. Never format a card in a computer because computers use file structures

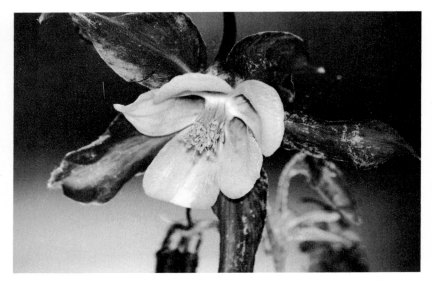

Here's proof you don't need to travel far to make photographs. This photograph of a purple Columbine, Colorado's State Flower, was made in my front yard. I used my 50-200mm zoom lens at 200mm, so Shake Reduction was a plus, even with the 1/180 sec shutter speed. The pop-up flash was used to fill in shadows.

that are different from digital cameras, which could make the card unreadable. Do not open the card slot cover or attempt to remove a card while formatting; it may damage the card.

Cleaning the Camera

Having a clean camera minimizes the chance that dust will get on the Pentax K100D's sensor. Your camera bag should always contain some cleaning materials including an anti-static brush and microfiber cloth to clean the lens, a soft camel hair brush to dust of the camera, a towel for drying the camera in damp conditions, as well as a small rubber bulb to blow debris from the eyepiece and camera body.

Before rubbing with any cloth, blow or brush the bigger chunks of dirt from the camera. Blow and brush first, then

clean with a microfiber cloth. If there is any residue on the lens, you can use lens-cleaning fluid, but apply the fluid to lens tissue or the edge of your microfiber cloth.

Caution: Never put fluid directly on the lens because it could seep behind the elements and cause big problems later. Rub gently to remove the dirt and then buff with the cloth.

When shooting outdoors in challenging situations, consider using a UV or Skylight filter for your lenses. Both will protect your front lens from scratches and dents and are a lot cheaper to replace than a lens.

Cleaning the Sensor
Keeping your gear clean helps to prevent dirt from getting on the camera's sensor, but dust is inevitable. You can minimize problems by turning the camera off before changing lenses and keeping the lens or a body cap on the camera when you're not using it. Vacuum your camera bag from time to time, so that dust and dirt aren't stored with the camera.

Dust on the sensor often appears as a shadow on smooth, light colored backgrounds or skies. Pentax recommends that you contact a factory service center for professional cleaning, because the CCD is a precision part. However, if you have to clean it yourself (and I caution, do this at your own risk!), here are a few tips:
- Turn the camera off and remove the lens.
- Turn the camera on.
- Press the menu button and use the four-way-way controller to get to the Set-up screen and scroll down to [Sensor Cleaning].
- Push the right button to open the screen, select [Mirror Up], and click OK.
- Clean the CCD. Use a brushless blower to remove dirt and dust; a blower with a brush may scratch the CCD. While cleaning the sensor, the self-timer lamp will light and "Cln" appears on the LCD preview screen.
- Turn the camera off and replace the lens, or cover the lens mount opening with the body cap.

That's all there is to cleaning, but here are a few caveats:

- Losing power when cleaning the CCD can cause problems.
- When cleaning the senor be sure to use an AC adapter so you have a steady source of power during the operation.
- If power is lost, damage to the shutter and CCD can occur. I recommend that you leave it to the pros.

An important step in getting ready to start shooting is setting the [Quality Level], which can be accessed through the Rec. Mode menu.

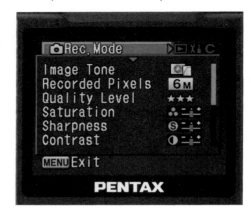

Getting Started in 10 Basic Steps

There are ten things you should check, which will make working with your Pentax K100D series camera easier the from the start. These steps are especially important if you are not familiar with all of your camera's controls and capabilities. Over time, you will probably modify these suggestions and make them fit your style and experience, they these will get you started.

The Starting Line-Up

1. Set the date and time. Having the correct time and date saved as part of the image file's EXIF data is important now and indispensable later when sorting through your photographs. Go to the Set-up tab in the Menu and set the time using the Date Adjust item to set Date Style, Date and Time.

2. Set Power Off for a workable time interval. If you keep it set really low, you will almost always have to restart the camera, and may miss some important shots. Setting it too high will waste battery power. Start by trying ten minutes. Change the Auto Power Off setting using the camera's Set-Up menu.

3. Adjust the eyepiece diopter until you can see clearly. Lightly press the shutter release to display the viewfinder information and slide the adjustment lever (located above the viewfinder), back and forth until the text is as sharp as possible. Never adjust it by looking the scene in the viewfinder.

4. Choose a [Quality] level of RAW or three stars—the largest JPEG size. This setting is found in the Rec. Mode ◘ menu near the top of the screen. Press the right button on the four-way controller, then use the up down buttons to select the image quality you want.

5. Choose your preferred shooting mode. Turn the mode dial to select any of the basic settings (P, Tv, AV, M, and B) or Scene modes (see pages 127-139). There is also an Auto Picture AUTO PICT mode, where the camera will automatically select from the available scene modes. This could be considered beginner mode and doesn't take full advantage of the camera's capabilities, but will produce great-looking snapshots when you're getting started.

6. Select a drive mode. Press the **Fn** button, then the up button in the four-way controller to select one of the seven possible settings and scroll through them using the right-hand button. Choices include: single frame shoot-

ing, continuous shooting, self-timer (12 secs), self-timer (2 secs), remote control unit, RmoteCon (with electronic cable release), and auto-bracket.

7. To set the AF mode, press the MENU button. In the Rec. Mode menu, choose [AF Mode]. Press the right button on the four-way controller to see a menu that offers two choices: The default [AF.S] (Single AF) is activated when the shutter release button is pressed halfway to bring the subject into focus. In [AF.C] (Continuous AF), the subject is kept in focus by continuous adjustment, while the shutter is pressed halfway.

8. Select the white balance. Press the **Fn** button, then the left button in the four-way controller, to see the [White Balance] options. Use the down button to make a choice from: [AWB] (auto white balance), [Daylight], [Shade], [Cloudy], three kinds of [Fluorescent], [Tungsten], [Flash], and [Manual] white balance set. White balance cannot be adjusted when the camera is in AUTO PICT mode.

9. Pick an ISO Setting. Press the **Fn** button, then the right button in the four-way controller to select an ISO sensitivity of 200, 400, 800, 1600, and 3200. There is also an [Auto Sensitivity] mode that picks an appropriate ISO for you. To keep the Pentax K100D series camera from picking ISO 3200, when you don't want it to, use the [ISO Corction in Auto] Custom Setting to place limits on the range that can be selected. Choices include: [200-800], [200-400], [200-1600], and [200-3200].

10. Set the [Instant Review] time. There are three choices in the [Instant Review] setting found under the Playback menu ▶ tab. Press the down button on the four-way controller to go to [Instant Review], then press the right button. Choose one (not recommended), three (to save battery life) or five seconds if you like to savor your shots. There is also an [Off] setting, when you're in a hurry and want to maximize the number of shots made in continuous drive mode.

Use the ten steps outlined in this section to prepare yourself for shooting.

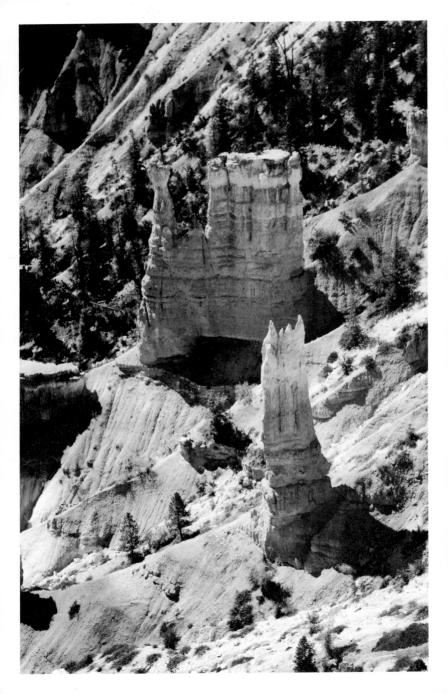

File Formats and In-Camera Processing

If you are new to digital photography, one of the topics that may seem complicated and intimidating is file formats. Not only will you need to learn about file types and resolution, but you'll also need to understand the term compression. Data compression enables devices to capture or store data in less space. It does this by discarding data that is redundant (a process called lossy compression), and rebuilding (or replacing) it later, when the file is uncompressed. How much data is discarded and rebuilt, or how well it accomplishes this, ultimately determines image quality.

All digital cameras use compression techniques to store JPEG images. The greater the compression ratio, the greater loss of quality you can expect. Less or lower compression produces better quality images. The highest image quality option is the RAW or PEF format in Pentax digital cameras, because the file is not compressed.

RAW files are unaffected by anything except the ISO setting. You might think of them as a negative that needs to be processed before it can be turned into the final photograph. RAW files contain all of the original data. Processing software is required to bring the final image that was lurking inside that original exposure to fruition.

This photograph of Bruce Canyon, Utah was created as a low compression, high-quality JPEG file.

There is some loss of quality with the JPEG process, but you can get more files on a memory card with compressed images. RAW files deliver the optimum image quality from your digital camera, but you'll need to buy more and bigger memory cards.

How do you plan to use your image files? If you just want a bunch of 4 x 6 inch (10 x 15 cm) prints of your vacation, some snapshots to e-mail, or enlargements for the top of the piano, JPEG is probably the best choice. If you are going to Yosemite to shoot pictures to sell at art fairs or as stock photography, shooting RAW probably makes more sense.

Speed

Computer geeks have a word for speed—throughput. It describes how much data can squeeze through the system and how fast it can be done. With a digital camera this relates to shooting speed, or frames per second (fps). This is determined by many factors; the most important two are the size of the image and the camera's buffer. The buffer is a temporary storage area that holds the images before writing them to the memory card. Pentax does not disclose the K100D's buffer memory size because they say, "there are several factors that effect the frame capture rate."

In 2.8 fps Continuous mode, the K100D series camera can shoot a single burst of up to five JPEG or three RAW files. Select Continuous Drive by pressing the Fn button, then the up button on the four-way controller to select one of seven possible Drive mode settings, which include single frame or continuous shooting. With Pentax K100D series cameras, the speed rating of the memory card does not affect the frame rate, but will have an impact the number of images you can capture. For example, a higher speed card may be able to capture five images at 2.8 fps, while a slower one can only process three images.

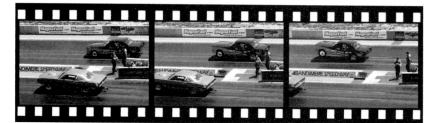

This three-image sequence shows the advantage of continuous shooting. The 35mm film replica was created with image processing software.

File Formats

One great feature of Pentax K100 series cameras is the ability to capture a RAW file. Unlike JPEG, RAW is a format that has little or no internal processing applied by the camera. RAW files contain 12-bit color information, which provides more data, but that data must be processed or "developed." Enhancements to Contrast, Saturation and Sharpness are not applied to the RAW image file by the camera's processor.

JPEG is the most common file created by digital cameras. A compressed JPEG's 8-bit file uses less memory than 12-bit RAW files. The K100D has a processing chip that evaluates the captured 12-bit image, makes adjustments to maximize the data, and then compresses the image with a reduced color depth of 8-bit to save the file in JPEG format. Because this process discards what it deems redundant data, JPEG is referred to as a lossy format. Keep in mind, however, that when the file is opened in a computer the lost data is rebuilt, especially well, if a low compression ratio was used.

Both RAW and JPEG files can give excellent results. A RAW file's unprocessed data file can be helpful in tough exposure situations, but the smaller size of the JPEG file is faster and easier to handle. For most purposes it usually doesn't matter whether an image originated as a RAW or

high-quality JPEG file. What matters to art directors, clients, or friends and relatives is the appearance of the image. How it communicates and how well it fulfills its purpose as a snapshot, a framed piece of art, an email attachment, or a magazine photo is also important.

Both JPEG and RAW files produce acceptable results, but if you want the best image quality from the Pentax K100D series cameras RAW does have the slight edge for large exhibition quality prints—if you want to spend the time in the digital darkroom to extract the maximum image quality. Test both formats using your K100D series camera and software and decide if anything is gained in using one format over the other.

RAW Exposure Processing

At the height of the darkroom era, practitioners jealously guarded their formulae for processing film. They would never reveal, for free anyway, that precise blend of Rodinal, grain alcohol and rainwater, along with a shot of Dr. Pepper—that rewarded them with the perfect negative.

There are also many choices available for processing RAW files. You can use camera manufacturer's software (which is an advantage because it has been designed specifically for that model's PEF files), or you can try other processing programs that make conversions from RAW files. Adobe Photoshop (professionally priced) and Photoshop Elements (popularly priced) offer an Adobe Camera RAW plug-in that reads many different kinds of digital cameras, including those from Pentax. This means you can open a PEF RAW file directly in Photoshop or Elements, do the processing, and then continue to work on the image file using the program.

Was this image made in JPEG or RAW? Can't tell, can you? This ⇨
photograph of the koala was made with K100D in Australia where
these little marsupials are endangered. © Hisashi Tatamiya

Adobe Camera Raw (ACR) provides fast and easy access within Photoshop to the RAW format images produced by many professional and midrange digital cameras. By working with these "digital negatives," you can achieve the results you want with greater artistic control and flexibility.

Hint: If you are working with Photoshop or Photoshop Elements, make sure that you have a version that is later than 3.4 to read files created with Pentax K100D series cameras.

The disadvantage of some RAW conversion programs is that they are not integrated into image-editing software. This means you have to open and work on your photo, then save it and reopen it in an editing program, such as Adobe Photoshop or Elements.

70

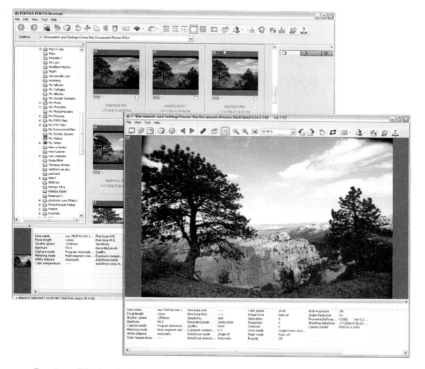

Pentax Photo Laboratory and Pentax Photo Browser will help you sort and process your images after downloading them to the computer.

Whichever way you decide to access RAW files with your computer, the format provides more control over the color and exposure of the photograph. The image will appear showing the exposure settings you selected when you first shot it, and you can then change these exposure values without harming the file. Most RAW software also allows batch processing. This allows you to adjust a group of photos to specific settings and can be a very useful with lots of photographs from the same shoot.

Image Size and Quality

Mies van der Rohe's famous quote, "Less is more" certainly doesn't apply to digital image quality. More is usually better! Pentax K100D series cameras offer ten choices for image recording, with a combination of file formats, resolutions and compression. If you're interested in image quality, most photographers will shoot with the camera set on the maximum image resolution with RAW or low compression JPEG files.

With the Pentax K100D series cameras, you need to choose image size and compression: To change image resolution in megapixels (M), press the MENU button and select the Rec. Mode menu. Then, scroll down to [Quality Level]. Pressing the right button in the four-way controller presents three JPEG file sizes including: 6M (3008x2000), 4M (2400x1600), and 1.5M (1536x1024.) [Quality Level] sets the amount of compression in four levels: the first—RAW, has no compression. Next, choices represented by stars range from three stars—the minimum compression/maximum quality, to one star—the maximum compression/minimum quality.

Pentax designed the settings to maintain the maximum picture quality. The amount of compression that is applied depends on the actual amount of data a picture contains. Pentax doesn't quote actual compression ratios, because they vary based on the image's color makeup. However, Pentax told me that, since the original data for a six megapixel image file can be as large as 18MB, compression assumptions are as follows

6M ★★★	20% of the original file size
6M ★★	10% of the original file size
6M ★	6% of the original file size

Three stars is the lowest compression/highest quality and Pentax says that it is suitable for printing pictures up to

11.69x16.54 inches (A3, or 297x420 mm), although I have made excellent quality 13x19-inch (330x482 mm) enlargements from this compression choice with the largest JPEG file. Two star images are suitable for small prints or viewing on your computer screens, while one star is recommended for use as an email attachment.

The default is 3008x2000 (JPEG), but Pentax claims that 1.5M files will make acceptable 4 x 6 (10 x 15 cm) prints and I expect that's true, although I would rather have a big file just in case I wanted to make a larger print. I believe that since you paid for your camera's resolution and quality, you might as well use all of it!

Remember, every choice you make affects how many photographs will fit on your memory card. The chart below provides an estimate of approximately how many images will fit on a 128 megabyte SD card; you can see that JPEG gives you a noticeable advantage over RAW in storing images.

Images that will fit on a 128 MB Memory Card:

Recorded Pixels	RAW	Best (***)	Better (**)	Good (*)
6M (3008x2008)				
6M (3008x2008)	11	34	70	117
4M (2400x1600)		51	96	161
1.5M (1536x1024)		106	173	271

The Digital Filter Menu

The Pentax K100D series cameras can make some image adjustments or enhancements, but not at the time the exposure is made. These include: Black & White, Sepia, Color (18 types), Soft (3 levels), Slim, and Brightness. RAW images cannot be processed using Digital Filter. The key to using these features is found in the Digital Filter menu, which is part of the Playback menu.

After processing an image, click the OK button, you'll be prompted to "save as" of "cancel." Clicking OK causes the screen to blink with the words, "data is being saved" and the camera will save the processed image under a new file name. The original color image will remain untouched.

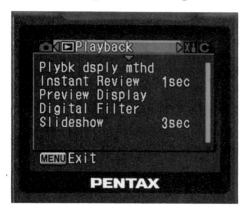

To process image files in-camera, press the Menu button, then use the left button on the four–way controller to go to the Playback menu. Push the down button to go to Digital Filter then press the right button to see your choices.

- **[Black & White]**

 This filter converts a color image into a black-and-white photograph. Sometimes this adds drama and simplifies a photograph, focusing attention on the subject itself, not its color.

- **[Sepia]**

 You can add a vintage, nostalgic touch with this filter to produce a warm monochromatic brown tone. Yes, I know you can apply these effects using your favorite digital imaging program, but doing it in-camera lets you make prints at a kiosk, without ever having to load the files onto a computer.

Even at a three star setting for [Quality Level] and 6M Recorded Pixels, you will still be able to store three times as many photographs on a 128MB SD card than you would with RAW capture.
© Hisashi Tatamiya

- **[Color]** (18 steps)
 Want more than just a sepia tone? The Color filter lets you apply nine color filters with two tones ranging from dark magenta to light magenta with sixteen stops in between at various cyan and yellow tones. This filter can be applied to already filtered and saved black-and-white images to produce a range of warm and cool tones that are different and more dramatic than the single sepia tone. Roll the e-dial back and forth and the LCD screen previews what the image will look like.

Hint: Pentax considers this to be a special effect filter, but the choices of colors used make it ideal for color correcting images when your image's white balance is off.

- **[Soft]** (3 levels)
 This filter lets you add a soft focus effect by lightly fading the entire image. You can select from three levels of softness—just by turning the e-dial.

- **[Slim]**
 This filter lets you change the horizontal and vertical aspect ratio of image files and lets you manipulate the photograph's height or width up to two times the original size.

Adobe Photoshop's Image Size command lets you accomplish the same kind effects as the K100D series camera's Slim digital filter, but the software costs more than a K110D! And you get to do it in-camera—without a computer.

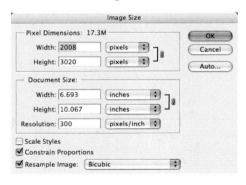

- **[Brightness]**
 If your original photograph is a little too dark or bright, this filter allows you to apply eight brightness levels (plus

This bucolic scene was photographed using a Pentax K100D and smc 12-24mm lens at 18mm. Softness was applied, using the camera's [Soft] Filter number three, to add a moody effect.

or minus) to a captured photograph. As with all of these digital filters, this can be done later in the digital darkroom, but doing it in camera lets you print directly from a memory card.

White Balance

While our eyes tend to adjust for slight variations in the color of light, cameras record things as they are. This explains the reason why people shot under fluorescent light appear green or your white walls appear yellow in lamp-lit pictures of your living room. The lighting in the pictures really is the color the camera recorded, but our brain adjusts our perception so the view we see with our eyes appears to be normal.

With film photography you had to use gels or filters to make pictures appear more natural, but all that's changed with digital cameras. Built-in color correction has long been a part of shooting video where the camera's electronic circuits can be set to neutralize whites without requiring filters. Pentax K100D series cameras can check color temperature using the [Auto White Balance] (AWB) setting, and automatically compensate for the light's color. The camera's white balance can also be set to specific light conditions, or it can be custom-set for any number of possible mixed lighting conditions. Color correction filters are rarely, if ever, necessary.

Setting white balance is easy. Press the **Fn** *button, then the left-hand button in the four-way controller to see the preset white balance settings that are available on K100D series cameras.*

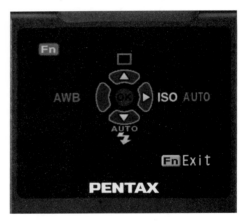

[AWB] is not always perfect because color rendition is subject to highly personal interpretation. What looks right to me may not look right to you. And sometimes a scene just doesn't "feel" right when shot using the camera's auto corrections. For example, the camera will automatically apply a neutral balance to a warm sunrise or sunset, which won't convey the drama of nature's warm glow.

If you want the effect of the warming filter without the hassle, press the **Fn** button, then the left four-way controller button for [White Balance], and use the down button to scroll through the choices. On a bright sunny day try using the [Shade] or [Cloudy] setting to warm up the photograph.

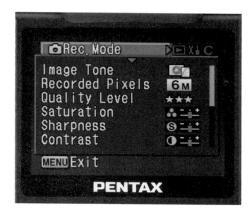

Color and light in nearly any scene can be made to look natural by using the camera's custom white balance setting. You can even adjust the camera so that it records scenes in hues that are intentionally warmer or cooler than a purely neutral rendition. In Record mode K100D series camera offer an Image Tone option with two choices—Bright or Natural—although cryptic icons identify them instead of words. [Bright] produces images that are snappier with more contrast and sharper focus. Selecting [Normal] produces photographs that are "finished naturally and suitable for retouching." Reading between the lines it means less contrast, slightly lighter, and softer focus.

AWB Auto White Balance

The camera's [AWB setting automatically interprets the light, within its range of parameters (4000 - 8000K), and adjusts accordingly. Sometime this works extremely well, and depending on the mix of light sources, sometime it doesn't. Sometimes it works better with some lenses than others and images made with a wide-angle lens may have a slightly different color balance than those made with lenses of a longer focal length. My philosophy has always been when the lighting gets tricky to try [AWB] first. I am amazed at how often this produces a pleasing color. If it doesn't, then it's time to look at the other options offered by the K100D series.

Preset White Balance Selections

The camera offers several preset white balance adjustments. These include: [Daylight], [Shade], [Cloudy], [Tungsten], [Fluorescent], or [Flash]. White balance adjustments cannot be made when you are in AUTO PICT mode.

☀ Daylight: Approximately 5200K

This is a bit of a misnomer because the color of daylight changes depending on the sun's position in the sky, but, in this case, it means that you're shooting "outdoors" and is based on midday (the worst time of day to photograph anything.) Shooting in this mode makes the colors look the way they should under the midday sun. If you use the [Daylight] setting indoors, with typical household lighting with a color temperature around 3200K, the pictures will have a warm, golden look. If you don't like the color of the images on the K100D's LCD screen, chances are you're using the wrong WB preset.

⌂ Shade: Approximately 8000K

[Shade] often adds a bluish cast to photos made with film. That's why many photographers use Skylight or warming filters when shooting in the shade. The K100D's [Shade] setting accomplishes the same thing.

☁ Cloudy: Approximately 6000K

This setting warms up images too, but not as much as the shade setting. In fact, you might prefer to use the [Cloudy] setting when making portraits in the shade since the effect is slightly weaker. It's also a good white balance setting to try for sunsets in order to punch up warm tones. This is where the K100D's series LCD preview screen exploits the digital advantage and encourages experimentation by letting you preview the effects.

☰ Fluorescent Light

Fluorescent light produces a greenish look to photographs and the K100D series offer three correction options: [D] is for daylight-balanced tubes (6500K), [N] works best with natural white (5000K) tubes, and [W] is suggested for white (4200K) tubes.

Hint: Since different types of fluorescent tubes are often combined in room lighting, make a few test shots using each of the three settings to find out which one works best. If you don't like any of them, that's the perfect time to try the camera's Manual white balance setting.

Hint: White balance presets can be used creatively. The [Fluorescent] options can be used to add a dash of pinkish warmth to sunrise or sunset images.

☀ Tungsten Light: Approximately 3200K

This setting is designed for photography under quartz or photoflood lamps that have a color temperature of 3200K, but works well under household lamps whose temperature varies, depending on wattage, but usually hovers around 2800K.

Hint: This preset cools the light and offers some creative opportunities for adding a blue cast to a snow or night scene.

⚡ Flash: Approximately 5400K

Light from electronic flash units tends to be cooler than daylight, so you can use this setting to warm up your images. This setting is similar to [Cloudy] and some photographers use both settings as of digital warming filters for outdoor scenes.

Manual White Balance

When none of the preset white balance settings work, use the [Manual] option. Sure, it's a little more labor intensive, but you'll be amazed how well it works under difficult and mixed lighting conditions like indoor exhibits, convention centers, and museums. Start by making sure that the mode dial is set for P, Tv, AV, or M, then press the **Fn** button. Use the four-way controller to select [Manual] white balance then photograph a sheet of white paper under the lighting conditions you want to correct.

After you make the photograph (no image is actually recorded when the shutter release is pressed to adjust white balance), press the OK button. If that image is extremely over or underexposed, proper white balance may not be achieved. If that happens, adjust the exposure accordingly and Press the Fn button to start over again.

White Balance Correction

If you are still not happy with the color balance of your photographs, you can try the [Color] filters found in the [Digital Filters] (Playback) menu. The Color filter lets you apply a tone that ranges from dark to light magenta with sixteen stops in between at various cyan and yellow tones. This filter can be used for manual color correction and is especially useful for the beginning SLR shooter, who doesn't want to use an image-editing program to correct colors. To use this:

Display your image on the LCD screen, go to the [Digital Filters] menu, and use the four-button controller to scroll down to the [Color] filter. Rotate the e-dial in different directions to see if the color improves. When you find the one that looks best, click OK and you will be prompted to save the corrected image as a separate and differently numbered file. Your original photographs remains untouched.

RAW and White Balance

Since the PEF (RAW) format allows you to change a photograph's white balance in the computer, you might be tempted to not worry about setting proper white balance when shooting in RAW. Don't. White balance choice is important, because most RAW processing software opens the file with the white balance setting used to make the photo.

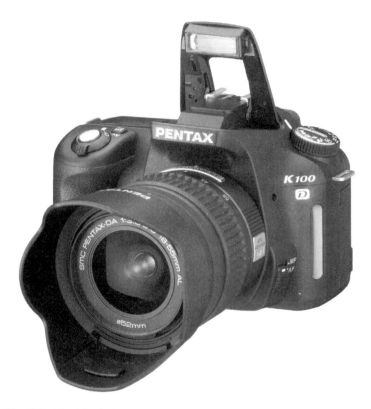

The [Flash] white balance setting ⚡ for the Pentax K100D series has been specifically designed to work with the camera's built-in flash, but it works just as well with accessory units such as the Pentax AF-540FGZ flash.

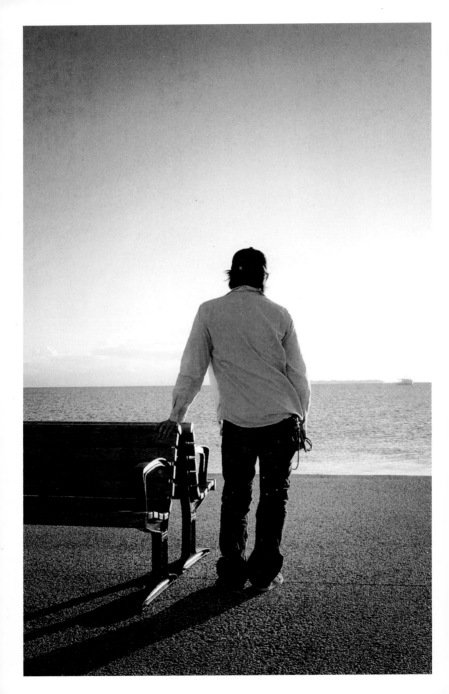

Camera Menus and the LCD Monitor

The menus in the Pentax K100D series cameras provide much control and flexibility for making photographs, but, at first, may seem a bit daunting. Nevertheless, let's jump in and see what they do and why. Don't forget, the menus can be set in 12 different languages so make sure the camera is set for your language preference.

Using the Menus

All entries and controls are found in four menus that are grouped based on application. Those categories (in order of appearance) are: [Rec Mode] (record/capture), [Playback], [Set-up], and [Custom Setting]. You gain access to a menu by pressing the MENU button and using the right-hand button on the four-way controller to flip through the four tabs. Pushing the down button in the four-way controller lets you scroll through the individual categories and, when you find one you want to change, pushing the right-hand button opens a menu that you can scroll though using the up and down buttons. When you make your choice, click the OK button and you're done.

↶ *Photographed on a beach in Australia as a horizontal, this image was cropped in the computer to isolate the subject and tell a better story.*
© Hisashi Tatamiya

The MENU button on the back of the camera to the left of the LCD monitor lets you select from a number of options and suboptions for shooting, playback, set-up, and the all-important Custom Settings.

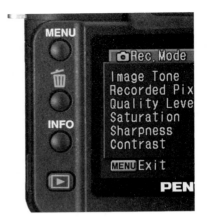

The Rec. Mode Menu 📷

The Record Mode menu 📷 is where you set the parameters for the photographs you will take; it offers the following choices:

- **[Image Tone]**—This sets the basic color tone of the photographs. There are two choices available: [Bright] and [Natural]. (The default setting is [Bright].)

 [**Bright**] images are sharp with bright colors and high contrast.

 [**Natural**] photos have a softer, more natural look.

- **Recorded Pixels**—Provides three choices for image quality. More pixels mean better quality, bigger files. File sizes can differ greatly depending on the quality level setting. The default setting is 6M, or six megabytes.

 6M : 3008x2008 is suitable for printing on about 11 x 16 inch (A3) paper.

 4M : 2400x1600 is suitable for printing on 8-1/2 x 11 inch (A4) paper.

 1.5M : 1536x1024 is suitable for printing on 5 x 7 inch (A5) paper.

- **[Quality Level]**—This menu item provides four choices for image compression: [RAW] (no compression is applied), [Best], [Better] and [Good].

86

RAW files take up a lot of memory card space and require process-ing with software such as Pentax Photo Laboratory. However, they offer more flexibility in image color and exposure.

[**Raw**]—The image file is uncompressed and does not include any other processing, such as: white balance, contrast, saturation, and sharpness. You will need pro-cessing software like the Pentax Photo Laboratory to work with the files.

[**Best**] is the lowest JPEG compression level available in the camera and is suited for files that will be used for making large prints.

Hint: This is the default setting and I recommend that you use this most of the time.

[**Better**] is produces JPEG image files that are suitable for viewing at high quality on your computer's monitor.

[**Good**] is the lowest level available in the camera and is satisfactory for creating JPEG image files that will only be used as email attachments or posted on the Internet.

- [**Saturation**]—Sets the camera to increase or decrease color saturation. I prefer to do this in the digital darkroom, but you may want to do it in the camera if you are printing directly from the camera. Use the left and right buttons in the four-way controller to increase or decrease saturation in five steps. Moving the slider to the right increases image saturation and moving it left, decreases it. (The middle setting is the default.)

- [**Sharpness**]—This hardens or softens outlines or edges in the photo. However, it won't make an out-of-focus image look sharp. A photograph is either sharp or it's not; shake reduction will help you get sharper results, but it's up to you to do the real work. Leave this alone except for direct printing applications, where you may want to apply a little sharpening.

- [**Contrast**]—Moving the slider increases or decreases image contrast. I prefer to do this in the computer. (Again, except for direct printing applications.) The middle position is the default.

- [**Auto Bracket**]—Bracketing is the frequently used technique of taking multiple images of the same subject at different exposure levels. Often done with subjects that have unusual reflectance or are difficult to meter, it provides a choice of photographs.

In [Auto Bracket] mode the first frame is exposed with no compensation, the second is given less exposure, and the third is given more exposure. Clicking the right button in the four-way controller lets you set these parameters. The first is the amount of difference, which can be set in one-half (or one-third) stop increments up to two stops; you select the fractional unit in the Custom Settings menu. The next parameter is the order of Shooting Images which can be

changed from the default of 0, -,+ to −, 0, + (for traditional-ist and my personal favorite) or +, 0, -. The auto bracket exposure setting will remain effective for twice the amount of time as the Meter Operating Time (default is 10 seconds).

• **[AE Metering]**—Choose the part of the focusing screen for measuring brightness and determining exposure. The choices are:

⊞ **[Multi-segment]**—This divides the screen into 16 parts and meters each portion to determine the appropriate exposure.

◉ **[Center-weighted]**—This measures the entire screen with emphasis on the center.

⊡ **[Spot metering]**—This mode meters only a small circular area in the center of the screen. It is helpful when working under difficult lighting condi-tions or in close-up photography.

• **[Switch dst msr pt]**—This feature refers to Switching the Distribution of Metering Points, which determines the part of the screen used for focusing. It has three options, which are displayed as icons in the following order:

AUTO [Auto Mode] where the camera selects the focus point.

⊞ [User Selectable Focus Points] where the photogra-pher determines the focus point using the 4-way controller.

■ [Spot Focus] mode.

• **[AF Mode]**—You can select one of two autofocus modes: [AF.S] and [AF.C].

[Single Mode (AF.S)]—When the shutter release is pressed halfway to focus on the subject, focus is locked. This is the camera's default setting.

89

[Continuous Mode (AF.C)]—The subject is kept in focus by continuous adjustment while the shutter release is pressed halfway.

- **[Flash Exp Comp]**—Compensating the flash lets you change the power output of the built-in flash. You can adjust it in a range of -2.0 to + 1.0 stops in one-half or one-third stops. ✴ blinks in the viewfinder to remind you when it is set. This feature can be extremely valuable when using the built-in flash for fill when photographing people. Setting flash compensation on the minus side will give you more realistic fill-flash outdoors with less of an "over-filled" look.

- **[Shake reduction]**—Not to be confused with the Shake Reduction OFF/ON button, located to the right of the K100D's LCD screen, this setting is used, with the K100D only, when working with older K-mount or 42mm screw-mount Pentax lenses (with a K adapter). It tells the camera's Shake Reduction software the focal length of the manual focus lens that's mounted.

Older Lenses and Shake Reduction

To use older K-mount or 42mm screw-mount lenses you will need to first change two Custom Settings: In the Custom Setting menu, scroll down until you see "FI with S lens used" and change the option to 2. The next function, "Using Aperture Ring" also needs to be changed to option 2. Once you have these set, you will be able to manually input the focal length of your older lens through the Shake Reduction option. See also, pages 53-55.

The Playback Menu ▶

The most sparsely populated of all K100D series camera menus, the Playback menu still contains very some useful options:

- **[Plybk dsply mthd]**
 The Playback Display Method option lets you decide what information you want displayed during the playback of images. In the first menu, [Date Styles], your choices include:

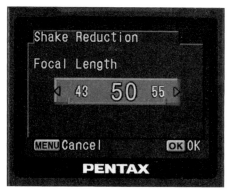

When using old manual focus K-mount or screw-mount lenses, you need to tell the K100D the focal length. Once you do this, you can take advantage of the Pentax K100D's Shake Reduction feature.

[Standard]: The image is displayed along with its file type and file number.

[Histogram]: Image file and its histogram are displayed.

[Detailed Info]: Image details appear with a small thumbnail of the photograph in the upper left hand corner.

[No Info display]: Only the image is displayed.

[Last Memory]: The settings from previous session are retained.

This Menu also provides for a [Bright Portion] warning that offers two options: OFF or ON. When it's turned on, the "bright portion" (aka blown out highlights) of the image blinks during playback. I usually keep this turned OFF, but picky photographers might want to see those blown out highlights so they can adjust exposure accordingly.

- **[Instant review]**
 This sets the amount of time that an image is displayed on the LCD screen immediately following the exposure. Choices include one, three, and five seconds as well as OFF. The default is one second, which is not enough for me to really evaluate the picture, so I keep set my camera at five seconds.

When the [Detailed Info] option is selected, the LCD screen displays complete image data along with a small thumbnail of the photograph in the upper left-hand corner.

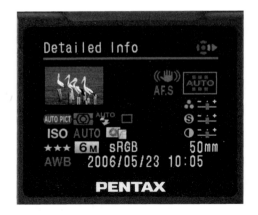

- **[Preview Display]**

 These options are for [Preview Display] only. The other, familiar sounding choices (above) are for [Playback Display]. The difference between them is that Preview is what is seen on the LCD screen immediately after exposing the image, and Playback occurs when you press the (blue arrow) Playback button ▶ , on the lower left back of the camera, to review one or more photos.

 This option offers two items with simple OFF/ON choices: [Histogram] and [Bright Portion]. This may seem a bit "old school" to some shooters compared to the similar options previously mentioned, but I prefer to see the histogram in [Preview Display], but not in [Playback Display].

- **[Digital Filter]**

 The [Digital Filter] options in the Playback menu include [Black & White], [Sepia], [Color] (nine colors plus two tones), [Soft] (three levels), [Slim], and [Brightness]. (See also pages 73-77.) The big difference between these filters, as well as the monochrome modes that are found in other digital SLRs, is that these effects are applied after you have made an exposure, not during it.

- **[Slideshow]**

 This option lets you play back all of the images on your SD memory card in sequence. The [Slideshow] option gives you choices of three, five, ten, or thirty seconds between slide changes. This feature may be more important when you are displaying your photographs on a TV set (we'll get into that later) than watching on the 2.5-inch screen.

- **[Set-Up]**

 This important menu contains all of the tools that will help you set-up your K100D series camera so that it works the way you want.

- **[Format]**

 Before using an SD card, you should format it. The formatting process deletes all of the data on the card, making room for the maximum number of image files. The menu provides two choices: [Cancel] or [Format]. To format the card, press the up button in the four-way controller to select [Format] and click OK. (See also, pages 57-58.)

- **[Beep]**

 You can turn the audible beep OFF/ON. The default setting is ON. I keep it that way because I like audio confirmation of focus, but some people find these kinds of camera noises annoying.

- **[Date Adjust]**

 This menu lets you change the date, time, as well as the style, of the calendar date, including 12 or 24-hour time. (See also, pages 50-51.)

- **[World Time]**

 The date selected in Date Adjust serves as your present location. If you change that location and want the EXIF data to reflect this fact, change the world time to reflect your new location.

This looks like a classic Florida image, but it was made in Australia. Ornithologists will recognize Pelecanus conspicillatus, which is found throughout Australia, New Guinea, and western Indonesia.
© Hisashi Tatamiya

- **[Language]**
 Once while on a trip, a man handed me his digital SLR and asked if I could help him delete a file. The problem was the menus were in Spanish and we couldn't figure out how to reset them to English. The K100D, on the other hand, simply lets you select the language from a menu of twelve choices.

- **[Guide Display]**
 On-screen guides appear on the K100D series cameras for three seconds when it is powered on, or if the setting has changed on the mode dial. You can turn the guide display OFF/ON by using the four-way controller to mark or unmark a check box. The less text I see on a screen the better, but some people may like this or find it reassuring.

Invite your friends for a "slide show" of your vacation trip. You can present your pictures on a TV set—you don't even have to set up a screen! Just make sure that, in the Playback menu, you have selected the correct TV/broadcast standard for your country. © M. Morgan

- **[Brightness Level]**
 This setting lets you adjust the brightness of the LCD monitor and it is useful if the screen is difficult to see in certain conditions. Press the MENU button and use the four-way controller to move to the Playback menu. Use the down button to move to [Brightness Level]. Clicking the right button on the four-war controller opens a pop-up menu that lets you move up or down the brightness scale, using the left and right controller buttons. Clicking the OK button in the center of the controller sets the level.

- **[Video Out]**
 When you connect the camera to audiovisual equipment like your TV set, you need to select the appropriate video output format, or TV standard. You have two choices: [NTSC] and [PAL]. [NTSC] (National Television Systems Committee) is used by the USA, Canada, and Japan; [PAL] (Phase Alternating Line) is used throughout Europe and other parts of the world. Select the one that matches the TV standard of your playback device.

- **[Transfer Mode]**
 This menu offers three choices for image data (file) transfer: [PC], [PictBridge], and [PC-F]. Choose [PC] when you connect your K100D series camera (with the cable provided) to the port on your computer. PictBridge is a

standard that lets you print images directly from the memory card in a digital camera to a printer, bypassing the need for a computer.

Note: PictBridge only works with JPEG files. Images captured in Pentax RAW (PEF) format cannot be printed with this setting.

[PC-F] is provided for use with older computers that may not have a USB 2.0 port. This setting locks the camera into USB 1.1 mode for transfers to computers that cannot handle data with the faster transfer rate.

- **[Auto Power Off]**
 You can set the camera to automatically turn off after one, three, five, ten, or 30 minutes of inactivity. If you turn this feature OFF, the camera will stay on continuously and will not power down when not in use. The default setting is one minute, but that seems very short. I use 30 minutes, but ten might be a prudent compromise for most users. You can reactivate the camera at any time by partially depressing the shutter release.

- **[Folder Name]**
 This menu item offers two choices for naming a folder: Under the [Std] (default) option, your memory card will contain a folder named "DCIM" which in turn holds a folder typically called "100PENTX" containing all your image files. In [DATE] mode, you'll still have the "DCIM" folder, but inside are a series of folders named by date containing all of the image files captured on that day.

- **[File Name]**
 When a new SD card is inserted, this menu allows you to set the file number for the images that will be written to the card. Options include: [SerialNo] (default) and [Reset]. With [SerialNo] the file number for the most recently captured image is placed in memory and the file numbering system continues with the new card. With the [Reset] option, every time an SD card is inserted, file

numbering starts with the lowest possible number. When an SD card that already has stored images on it is inserted into the Pentax K100D, the numbering continues starting from the last stored file number. If you want more information about using file and folder names, read the section called "Memory Cards" that starts on page 55.

- **[Sensor Cleaning]**
 This control opens the camera shutter and flips the mirror up and out of the way so you can clean the sensor. You have two choices: [Cancel] or [Mirror Up], which raises the mirror and makes the sensor accessible. When you're finished, turn the power OFF to set everything back to normal. For more information on cleaning the sensor, see pages 59-60.

- **[Reset]**
 This menu gives you two options: [Cancel] and [Reset], which returns all of the settings in the Rec Mode, Playback, and Set-Up menus back to the factory-set defaults. [Date Adjust] and [World time] are not reset by this command

The LCD Monitor

The camera's 2.5 inch (6.35 cm) Low Reflection TFT (Thin Film Transistor) color LCD screen has 210,000-pixel resolution, 140-degree viewing angle, and a 12 x zoom feature.

Photographers moving up from point-and-shoot cameras will note that the LCD screen on a digital SLR does not provide a live view of the subject. This is because the mirror in the viewing system of a single-lens-reflex camera blocks the light coming through the lens from reaching the sensor until it moves out of the way, when a picture is taken. Unlike the viewfinder, which shows 96% of the captured image, the LCD screen shows 100% of it.

Like all LCDs this one can be difficult to view in strong daylight and Pentax provides a Set-up option ("Brightness Level") that lets you increase the screen's brightness. Don't

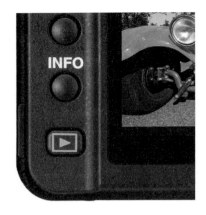

The Playback button, on the lower left, controls many of the image review and playback functions.

do it. Setting the brightness level too high can provide a distorted version of the photograph. Keep the setting in the middle and view images in the shade.

LCD Image Review

The LCD monitor screen is used for reviewing and editing images. [Instant Review] in the Playback menu sets the amount of time an image will be displayed on the LCD screen after you make an exposure. Choices include: one, three, five seconds, and OFF. Battery conscious users will choose OFF or one second. I prefer five seconds, although it does shorten battery life.

Playback

The Playback button is used when you want to review your pictures on the LCD. The left and right buttons in the four-way controller are used to advance to the next picture or return to a previously viewed image. By pressing the right button you move forward, the left button takes you back. If you stop at any point and turn off the screen, the camera remembers where you were and starts with the last image you viewed, instead of taking you back to the first picture again like some other digital SLRs do.

You can review the image you just shot in the LCD monitor and, if you are not satisfied with the results, reshoot the photo.

You can change the way that images are displayed on the LCD screen using the [Playback Display] Method options in the Playback Menu. This menu lets you decide what information you want to see during the playback, including: [Standard], [Histogram], and [Detailed Info]. As an alternative, you can change the information that's initially displayed by repeatedly pressing the INFO button and you will see all of these same Playback Display Method] options appear.

Rotate

Images are usually displayed using the full LCD screen. This means you have to turn the camera to view vertical (portrait format) pictures. You can make the LCD monitor show both vertical and horizontal pictures in the same viewing position. It's easy to do: In Playback mode, press the down button in the four-way controller. Each time the button is pressed, the image rotates 90° counterclockwise. Press the OK button to lock the photo into the position you want.

Nine-Image Display

If you want to look at groups of images at one time, this feature lets you look at nine thumbnails at once. In Playback mode, turn the e-dial to the left (toward the 🔳 icon) and up to nine images will be displayed. You can press buttons on the four-way controller to select an image. If there are more than nine pictures on the card, a scroll bar will appear

Reviewing your pictures on the LCD screen helps you can decide which shots to keep—I recommend you protect those images. Editing while you shoot creates space on the card and saves downloading and processing time later. © Hisashi Tatamiya

on the left-hand side of the screen. When an image in the bottom row is selected, pressing the down button in the four-way controllers displays the next nine photos.

Magnifying the Image

By using the camera's zoom controls you can magnify images up to 12 times during playback. This can be especially useful to check the expression on a portrait subject's face, to make sure the subject didn't blink, or to check for sharpness. Start by using the left and right buttons on the four-way controller to select the image you want to examine in detail. Next, turn the e-dial to the right toward the magnifying glass icon. Each click enlarges the image and you can proceed up to 12 times magnification. Turning the e-dial to the left (toward the ▧ icon) reduces the magnification. Press the OK button to return the file to its normal size in the LCD screen.

Note: The first click of the e-dial is 1.2X. You can change this first step by using the [Strt Zm Plyback] Custom Setting.

Erasing Images

Not only does the camera let you preview images, it also will allow you to delete any that you don't want. To delete a single image use the four-way controller to select an image. Press the Delete 🗑 button. This gives you two choices: Cancel, in case you accidentally hit the button or Delete to erase that specific image.

Caution: An icon in the lower left-hand corner will let you erase "all images" by pressing the 🗑 button. Don't do it unless you actually want to erase all images on the card. Pressing the trash can button twice gives you the choice of [Cancel] or [Delete] All.

Hint: if you've already saved all of the images onto your computer's hard disk and then backed them up on CD/DVD, don't use this command to "clean up" a memory card. Formatting is the best way to do this because it permanently erases everything on the card and prepares it to accept new files.

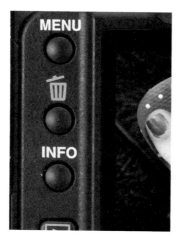

The 🗑 button is used to delete image files one at a time, or in groups.

101

If you want to delete a group of selected images you can do it by putting the camera in nine-image display mode. Start by pressing the Playback button, and then turn the e-dial toward the ⬛ icon. Nine images will be displayed. Next, press the 🗑 button and it will superimpose small rectangles in the upper right-hand corner of all of the images on the card. These are check boxes. Use the four-way controller button to move to an image you want to delete and press the OK button to place a check in that box. When finished making your choices, press the 🗑 button. If you want to delete all of the images, use the up button to choose [Select and Delete] and press the OK button.

Accidentally Erased Important Images?

Lexar (www.lexar.com) includes a free copy of Image Rescue with their PRO memory cards. You can also purchase a copy. Every SanDisk Extreme III memory card comes with their RescuePRO software. If you prefer a non-brand specific approach to image file recovery, take a look at PhotoRescue (www.datarescue.com.) It's available for both Microsoft Windows and Mac OS X and will undelete, unerase, and recover lost image files from corrupted, erased, or damaged CompactFlash, SmartMedia, Memory Stick, xD, MMC, or Secure Digital memory cards. It even works with cards that have been formatted. In some cases, PhotoRescue can rebuild pictures that have minor file corruptions.

Image Protection

Want to protect images so you can't accidentally erase them? In Playback mode, use the four-way controller to select an image. Press the button with the "key" icon that's located on the upper right back of the camera and then press the OK button.

You can also protect all of the files on a memory card. Start by pressing the blue Playback ▶ button on the back of the camera. Then press the ⛁ button twice. When the LCD screen displays a [Protect all Images] message, use the up button in the four-way controller to select [Protect] and all of images on the SD card will be protected.

PhotoRescue can recover lost, erased, or deleted image files from corrupted, erased, or damaged Secure Digital memory cards.

To protect images from accidental erasure, use the button next to the ⊙⃥ icon and follow the instruction in the text.

All of the images can be unprotected using the same procedure, except when the message on the LCD screen appears, simply choose "Unprotect." When viewing images on the LCD screen in playback mode, protected images display ⊙⃥ in their upper left-hand corner.

Remember the old days of setting up a projector and screen to show off your photos? Not any more! Pentax supplies a cable that lets you show your pictures on a TV set. It is a great way to show your family vacation photos to friends and relatives.

TV Playback

You can show your pictures to a group by connecting the camera to a television set; the cable for this purpose is supplied in the box with the camera. Connect that video cable to the Video/PC port hidden behind a door on the left-hand side of the camera. Connect the other end of the cable to the Video-In jack on the television. Then, just turn the TV and camera ON. If you plan to watch photos for an extended period of time, it's a good idea to connect the AC cable to the camera body instead of wearing down its batteries.

Hint: Some TV's have multiple video-in jacks, so be sure to check the TV set's operating manual, and use the remote to select the input you are using.

Custom Setting (CS) Menu

Like most sophisticated SLRs, the Pentax K100D series cameras can be tailored to your personal shooting style through the option Custom Setting menu. Some photographers never use these, while others use them all the time. Pentax K100D series cameras offer 21 different Custom Settings found

Noise, which is similar to grain in film photography, may appear in digital images made with long shutter speeds. Be sure to turn on the [Noise Reduction] feature to help eliminate this form of image degradation. © Hisashi Tatamiya

under the fourth tab when you press the MENU button. It's marked "C" but expands to "Custom Setting" when selected using the right button on the four-way controller. Sometimes a brief description will appear when a specific setting is selected. Here is a brief summary and commentary on all of the K100D series custom settings:

• **[Setting]**
 This is a check box that lets you decide if you want to apply settings in the Custom Setting menu. You can change this by clicking the right button on the four-way controller. If the box is checked, Custom Settings are applied; if it is unchecked, default settings are active.

• **[Noise Reduction]**
 [Noise Reduction] reduces image noise caused by long exposures. If you choose ON, noise reduction algorithms

will automatically activate with slow shutter speeds. Use the four-way controller to select your option and push the OK button.

- **[Expsr Setting Steps]**
 [Exposure Setting Steps] lets you choose the fractional increment for making adjustments to exposure. Choices include one-half or one-third stop. I use one-third, because it provides smaller increments and more subtle control over exposure.

- **[ISO Correction in AUTO]**
 This is important when you have the ISO set to AUTO mode. The four options automatically correct the sensitivity, within an acceptable ISO range. Use the up and down buttons on the four-way controller to make your choice. The default is ISO 200-400, which is what I recommend for most shooting.

 1 **[ISO 200-400]**—Automatically corrects sensitivity within the range of ISO 200 to 400
 2 **[ISO 200-800]**—Automatically corrects sensitivity within the range of ISO 200 to 800
 3 **[ISO 200-1600]**—Automatically corrects sensitivity within the range of ISO 200 to 1600
 4 **[ISO 200-3200]**—Automatically corrects sensitivity within the range of ISO 200 to 3200

- **[ISO Snstvty Wrn Dspl]**
 The ISO Sensitivity Warning Display option sets the maximum ISO level at which you would like a warning to appear.

Hint: Choose an ISO that you don't regularly use and it will remind you to reset it if you occasionally use it. The default setting is OFF, but you may prefer to explore the options offered here.

1 **[Off]**—ISO sensitivity warning is not displayed
2 **[ISO 400]**—ISO sensitivity warning is displayed when ISO 400 is set or exceeded

3 **[ISO 800]**—ISO sensitivity warning is displayed when ISO 800 is set or exceeded

4 **[ISO 1600]**—ISO sensitivity warning is displayed when ISO 1600 is set or exceeded

5 **[ISO 3200]**—ISO sensitivity warning is displayed when ISO 3200 is set or exceeded

- **[Link AF Point and AE]**
 Pentax K100D series cameras offer three metering methods: multi-segment, center-weighted, and spot. The default is multi-segment, but center weighted metering mode is automatically set when using a lens other than a DA, D FA, FA, J, FA, F, or A lens.

 In [Link AF point and AE, you can link the exposure and focus point when using multi-segmented metering. The default setting is OFF, with exposure set separately from the focus point. When tuned ON, exposure is biased for the focus point.

- **[Meter Operating Time]**
 This custom function sets the camera's active metering time to your choice of 10, 3, or 30 seconds.

You can control the amount of time the camera's meter is active using the top choice on this screen.

- **[AE-L with AF Locked]**
 If the subject is outside of the focusing area, you can place a focusing point on the subject, press and hold the shutter part way to lock focus, then recompose. This Custom Setting is designed to lock exposure at the same time that focus is locked.

107

- **[Recordable Image No.]**
 This changes the recordable images readout on the LCD panel and in the viewfinder. [Option 1] displays the number of recordable images for the memory card in use. When the shutter release button is partially depressed, [Option 2] displays the number of recordable images available for continuous shooting

- **[OK Btn when shooting]**
 This determines how the OK button is used:
 1 **[Setting 1]**—Displays the ISO in use in the LCD panel on top of the camera, and in the viewfinder. This is convenient for quickly checking the ISO during shooting.
 2 **[Setting 2]**—When you use the selectable AF point mode, pressing the OK button re-activates the central AF point.
 3 **[Setting 3]**—This setting disables activation of the AF system by partially depressing the shutter release. Instead, pressing the OK button activates it. This is recommended with any Pentax lens that has the "quick-shift" function (all DA series lenses).

Note: The Quick-Shift Focus System allows the photographer to first capture the subject focus in AF mode, then move to Manual focus without the need to perform mode switching operations.

 4 **[Setting 4]**—This setting is similar to above except the half-press of the shutter release is disabled only when the OK button is pressed. [CHECK THIS]

- **[AE-L bttn on M expsr]**
 In Manual mode, the aperture and shutter speed are automatically adjusted to the proper exposure if the AE-L (Auto Exposure Lock) button is pressed. You have three choices of how this is accomplished: [Option 1 (Program Line)] sets the aperture and shutter speed to the exposure that would be determined in Program Mode. [Option 2 (Tv Shift)] the aperture is locked and the shutter speed shifts to achieve the correct exposure. [Option 3 (Av Shift)] the shutter speed is locked and the aperture is shifted to set the correct exposure.

- **[Superimpose AF Area]**
 This Custom Setting allows the selected AF point to be displayed in the viewfinder as a red light. Two choices: [ON] (the default) and [OFF]. I keep it on, but those shooters who prefer to minimize viewfinder distractions might want to turn it off.

- **[AF in remote control]**
 The optional Remote Control F lets you shoot pictures wirelessly up to 16 feet (5 m) from the camera. This custom function lets you turn the AF system off or on when the remote control is used. Choosing the [OFF] setting means that the camera's AF will not operate when the camera is fired by the remote control unit. Turning it [ON], means that when triggered by the remote, the camera must focus before the shutter will only be released.

- **[Focal Length with S lens used]**
 This is an important function to use with Manual focus Pentax K-mount or screw-mount lenses. (That's kind of what this enigmatic description says—focal length with screw-mount lens used.) There are two choices: [Available] means that, when an older lens is attached, the focus indication will function. [Unavailable] means the focus indication will not function. Having focus confirmation available with these lenses is both a help and a hindrance, that's why I'm glad there is a choice. I like it [Available] when the light is low, and Unavailable when shooting outdoors.

- **[Using Aperture Ring]**
 Under the [Permitted] option, pictures can be made when the aperture ring is set to something other than "A." Under the [Prohibited] option, pictures can be made only when the aperture ring is set to "A." Now here are the caveats: Some features will be restricted as shown in the below table. When the aperture ring is set to any value other than "A," the camera will operate in Av (Aperture Priority) mode even if the mode dial is set to P or Tv.

This photograph was made with a brand new Pentax K100D and a 25-year-old 135mm manual focus Takumar f/2.5 lens. In bright light, the lens was easy to focus, so focus confirmation was a distraction. Under low-light conditions, I'd want focus confirmation turned on.

Pentax Lens Used	Exposure Mode	Restriction
S FA, FA, F, A, M (lens only or with auto-diaphragm accessories such as extension tube K)	Av (Aperture Priority)	Aperture remains open regardless of aperture ring position. Shutter speed changes in relation to aperture but exposure error may occur. Viewfinder displays [F—] for aperture indicator.
S FA, FA, F, A, M, S (with auto-diaphragm accessories such as extension tube K)	Av (Aperture Priority)	Pictures can be taken with the specified aperture but exposure error may occur. Viewfinder displays [F—] for aperture indicator.
Manual diaphragm lens (such as reflex lens)	Av (Aperture Priority)	Pictures can be taken with the specified aperture but exposure error may occur. Viewfinder displays [F—] for aperture indicator.
FA, F Soft, 85mm, FA Soft, 28mm	Av (Aperture Priority)	Pictures can be made with the specified aperture in the manual aperture range. Viewfinder displays [F—] for aperture indicator. When depth-of-field preview is checked, AE metering is switched on. Exposure check is possible.
All lenses	Manual mode	Picture can be made with the set aperture and shutter speed. Viewfinder displays [F—] for aperture indicator. When depth-of-field preview is checked, AE metering is switched on. Exposure check is possible.

- **[Release when Chrging]**

 ON enables shutter release while the built-in flash is charging; OFF disables the shutter release while the built-in flash is charging. That's where most of us should leave it.

- **[Preview Method]**

 This is an interesting Custom Setting that lets you capture, but not store, an image by using the depth-of-field preview feature of the main switch. By choosing [Digital Preview], the image is temporarily captured and displayed on the LCD screen when you use the Main Switch's depth-of-field check. [Optical Preview] stops the lens down to the selected aperture so you can preview depth-of-field in the viewfinder. Depending on your working style or what you're shooting at the time each one offers some advantages.

- **[Mag to Strt Zm Plybk]**

 This sets the starting magnification for the zoom feature in image playback. There are five options: 1.2X, 2X, 4X, 8X, or 12X. I prefer 2X.

- **[Man WB Measurement]**

 This Custom Setting gives you two choices of how manual white balance will be performed by the camera. You can set it so that white balance is measured across the full image, or you can set it to use the small area spot metering area. This is a good choice if you only have a small white surface to measure.

- **[Color Space]**

 The [Color Space] choices available in this custom setting are [Adobe RGB] and [sRGB]. Computer monitors are RGB. Most popular desktop printers use CMYK (cyan, magenta, yellow and black) inks but the software that drives the printer uses an RGB model to interpret the colors, so you're gonna need some help.

 sRGB was developed to match a typical computer monitor's color space and is the default for Microsoft Windows XP and other software running on the Windows platform.

The [Digital Preview] selection in the [Preview Method] Custom Setting allows you to capture and view an image without storing it.

It is also the color space that works best with on-line printing services and kiosks.

The [Adobe RGB] color space is designed for printing using CMYK inks and includes a wider range of colors (gamut) than sRGB. I keep my K100D set on [Adobe RGB] so I can capture the maximum number of colors and convert it to [sRGB] with Adobe Photoshop when I make prints via an on-line service.

- **[Reset Custom Function]**
 This custom function returns the Custom Settings to their defaults. If you are absolutely, positively sure that you want to do this, use the up arrow in the four-way controller to select [Reset] then push the OK button and you're back to square one.

Camera Operation Modes

The first thing your eyes recognize when looking at any image is sharpness, then brightness, and finally warmth. However, there are degrees of sharpness and some photographs may be "acceptably" sharp, while other, more carefully focused images made with a camera on a tripod and using small apertures might be termed "critically" sharp. I can hear some of you now, thinking, "All of my images are sharp!" But it's been my experience that, depending on how they are captured, some digital files are sharper than others.

Focus

The Pentax K100D series cameras use a high-precision SAFOX VIII 11-point autofocus system. SAFOX (or more correctly, SAFOCS) means Sensor Ability Fortifying Optical Compensation System. Nine of the eleven AF sensors are horizontally extended, cross-shaped type sensors that are aligned to cover the middle of the focusing screen, while two additional sensors are positioned at each side of this section. This allows the camera to automatically focus on the subject, even when it is positioned off-center in the viewfinder. For confirmation, the in-focus sensor point is automatically superimposed in red in the viewfinder. There is also the ubiquitous beep which, like the red focus points, can be turned off (see page 93). You can also manually select one of the autofocus sensors to accommodate a specific image composition.

This photograph was captured in at the Adams County Historical Museum with a 12-24mm smc Pentax lens.

AF Modes

The Pentax K100D AF system offers a choice of two autofocus modes: the conventional single AF (AF.S), and continuous AF (AF.C), which maintains focus on a moving subject as long as the shutter release button is pressed halfway. The default setting is AF.S. When focus is achieved, the focus indicator ● appears in the bottom center of the viewfinder. If it is blinking, your subject is not in focus. You can choose to set the K100D so focusing is only performed when the **OK** button is pressed, not when the shutter release button is pressed halfway. This option can be found in the Custom Setting menu (see page 108). This method of focusing is useful when you temporarily wish to use AF while in manual focus mode.

Single AF (AF.S)
Whether it's portraits, landscapes, or still life photography, most of the average photographer's shooting will take place in AF.S mode. Autofocus operation is initiated by lightly pressing the shutter release button halfway down, and the active AF sensor will glow red on the viewfinder. When the focus indicator ● lights up in the bottom center of the viewfinder, you can safely assume that your subject is in focus and trip the shutter. If the focus indicator in the viewfinder is flashing, the camera's AF system cannot focus on the subject area and the shutter is locked. In some cases, this may be because the lens is too close to the subject, meaning its minimum close-focus distance has been exceeded.

Continuous AF (AF.C)
This mode is perfect for tracking focus with a moving subject. The K100D keeps focusing as long as the shutter release button is held halfway down and the subject is moving. The movement of the subject is automatically tracked between the camera's eleven AF sensors. The K100D's autofocus system should even update focus between individual shots in a series. AF.C mode is selectable only when you are shooting in P, Tv, Av, M, or B exposure modes (see pages 127-139 for

Using Continuous AF mode will help you capture moving subjects such as this drag-race car.

more information about the K100D's exposure modes). The camera automatically activates AF.C mode when the Auto Picture Program or one of the subject or scene modes is selected.

Selecting an AF Point

There are several ways to select AF points in the K100D. One is to go into the ◘ Rec. Mode menu and select <Swtch dst msr pt>. You will then have three options:

- **[Auto Mode]** lets the camera select the optimum AF point, even if the subject is not centered.
- **[Select]** lets you set the focusing area to one of the eleven points in the AF area. Use the four-way controller to select the desired AF point.
- **[Center]** sets the focus area to the center of the viewfinder.

After [Select] is engaged through the [Swtch dst msr pt] feature in the 📷 *Rec. Mode menu, you can use any of the four buttons in the four-way controller to select the desired AF point.*

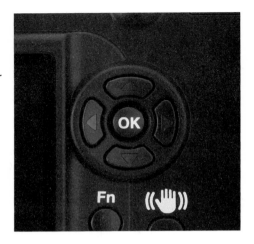

If the subject is outside the range of the focusing area, the K100D cannot focus on it. To use the camera's Focus Lock feature, just aim the focusing area toward the subject and partially depress the shutter release to lock focus. Keep the shutter depressed, then recompose and take the shot. There is a Custom Setting that determines whether or not exposure is fixed when focus is locked—see page 107 for more information.

AF Limitations

The AF mechanism is not perfect. Autofocus may be especially difficult when taking photographs under the following conditions:

- Extremely low contrast subjects
- Subjects that do not reflect much light
- Really fast moving subjects, such as race cars; in these situations, it's best to manually focus on a point and wait until the car reaches it before snapping the shutter
- Strong reflected light or backlighting
- When vertical or horizontal patterns appear within the focusing area

If all else fails, set the focus mode lever on the left front of the camera to MF (manual focus). Look through the viewfinder, press the shutter release button halfway, and turn the focusing ring. You will hear a beep and see the focus indicator ⬢ *fully illuminated when the subject is in focus. © Hisashi Tatamiya*

- Multiple subjects in the foreground within range of the active focusing area, an especially common problem in macro photography

Drive Modes, the Self-Timer, and Shooting Remotely

K100D series cameras offer two shooting speeds: single frame shooting and continuous shooting up to 2.8 fps (frames per second). To select one of these, while the camera is in capture mode, press the **Fn** button, then press the up arrow on the four-way controller. You can also select to use remote control, the self-timer, or auto bracketing (see pages 140-141) from here. Each press of the right button in the four-way controller cycles the camera through these modes and the chosen mode appears in the LCD panel.

The camera has two self-timer settings. For the standard self-timer, the shutter releases after twelve seconds. This setting is often used when the photographer wants to have time to get in to the picture. If, on the other hand, you are simply using the self-timer to reduce the possibility of camera shake, the two-second self-timer may be the better selection. This two-second option somewhat makes up for the lack of a mirror lock-up feature in the K100D and K110D. Another option for reducing camera shake is tripping the shutter remotely with the optional Remote Control F. In this case, the shutter will be tripped immediately after the release button on the remote control unit is pressed. You can also elect to have the camera wait three seconds to release the shutter after the remote control button is pressed. To do this, press the **Fn** button, then press the UP arrow on the four-way controller. Then use the four-way controller to highlight either ▐ telling the camera to release the shutter as soon as the button on the remote controller is pressed, or highlight ▐₃ₛ and the camera will wait three seconds before releasing the shutter.

Hint: When shooting remotely with Remote Control F, be sure to cover the viewfinder eyepiece with its cover or a piece of dark cloth to prevent stray light from entering the camera and causing exposure problems.

When using the ▐₃ₛ *remote option described above, the self-timer lamp on the camera's grip will blink to let you know the camera is in remote control wait status.*

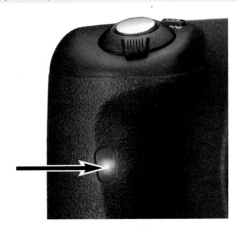

ISO

The first step in obtaining a proper exposure is selecting an ISO sensitivity that is appropriate for the shooting conditions. My favorite rule of thumb is to always use the lowest possible ISO that will deliver good hand-held results with as little digital noise as possible. The K100D's Shake Reduction feature helps with this, but depth-of-field is also critical for most shots, so keep the aperture in mind too. If you can't get the shot you want at the ISO you've selected, that's the time to try the next highest ISO setting. To select an ISO, press the **Fn** button, then press to the right on the four-way controller to show choices that range from ISO 200 to ISO 3200. There is also an AUTO setting, but I hesitate to use that unless I'm just taking snapshots.

Hint: When using the AUTO ISO setting, you can still have some degree of control though the [ISO Corection in AUTO] Custom Setting menu feature—see page 106.

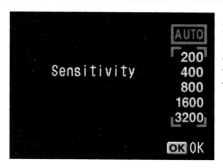

Press the **Fn** button, then press to the right on the four-way controller to show ISO sensitivity choices that range from 200 to 3200.

If you're new to SLR photography, here are a few guidelines to help you make decisions about what ISO to set:

- If you want to capture maximum detail in nature, landscape, and architecture, you'll want to shoot at ISO 200, the slowest ISO equivalent that K100D series cameras offer.
- Switch to ISO 400 for situations such as indoor window-light portraits, or when shooting with a longer focal length lens.

- Try 800 and 1600 when you are shooting under low light conditions. If you really need more to capture the shot, you can even select ISO 3200.
- If you're shooting with a tripod and your subject is not moving, use the slowest ISO speed to maximize image quality.

Metering

Since different parts of an image reflect light in differing amounts, no light meter—handheld or built-in—will produce a perfect exposure under all lighting conditions. That's why the K100D series cameras offer three different ways for measuring brightness and determining exposure: multi-segment, center-weighted, and spot metering. To select the type of metering you'd like to use, go to the ◘ Rec. Mode menu and select [AE Metering].

Multi-Segment Metering ▣

The scene in the viewfinder is metered in 16 different zones, and the camera's CPU (central processing unit) automatically determines the level of brightness is in each portion. The main advantage of multi-segment over center-weighted metering is that the exposure is biased toward the active AF area, which may or may not be at the center of the viewing screen. Multi-segment metering also automatically applies exposure compensation based on a comparative analysis of the scene. If you wish, you can elect to link the active AF area to exposure during multi-segmented metering with the [Link AF Point and AE] feature in the Custom Setting menu (see page 107).

When shooting indoors, you can get good results with a relatively high ISO setting, such as the ISO 800 setting used to make this photograph. If you move outside to take more pictures, be sure to reset your ISO to the lowest possible setting to take advantage of the high image quality that low ISOs can achieve in good light.

Note: If you select multi-segment metering when using a lens other than a Pentax DA, D FA, FA, J, FA, F, or A lens, the camera will automatically revert to center-weighted metering.

Center-Weighted Metering 🔲

In this mode, the metering is weighted toward the center of the viewing screen. Use center-weighted metering when you want to maintain control over exposure compensation; in multi-segment metering, the camera compensates exposure automatically if it determines that it is needed.

Spot Metering ⊡

When spot metering is selected, brightness is measured only from within the circle at the center of the viewing screen. You can use this type of metering in combination with the Exposure Lock feature (see page 139) when the subject is small and proper exposure is difficult to obtain. This metering mode is perfect for backlit scenes; just be sure that your subject is within the spot metering circle and not in the background.

Judging Exposure

Looking at images on the 2.5-inch LCD monitor will give you some idea of how accurate or not your exposure was, but keep it is certainly not the best judge of accuracy. With experience, you will get better at understanding what exactly the LCD monitor is capable of showing you about exposure. To help you in this effort, the K100D series cameras include two features that assist you in evaluating whether an exposure is correct: Bright Portion and Histogram. You can select when you want the camera to display Histogram and Bright Portion by using the [Preview Display] settings in the ▶ Playback menu (see page 92).

Here's a case where the Bright Portion display helped me to determine whether or not this eagle sculpture photograph was overexposed. Some of the highlights were "blown out," but not enough to ruin the shot. ⇨

124

Bright Portion

This setting provides a highlight alert. When selected through the Playback menu, overexposed areas will blink on the LCD monitor when you review your images. These blinking areas are so overexposed that they are essentially pure white with no other image data. If you find that significant parts of your subject are blinking, the entire image is likely overexposed and you may want to reshoot. This feature is helpful for indicating which highlights in the photograph will be "blown out," but I find that, with a little bit of practice, a glance at the LCD monitor even with this feature turned off can tell you the same thing. I prefer to use the Histogram feature to evaluate exposure.

The Histogram

The Histogram feature offers you a chart that shows the darkest and brightest portions of an photo. This is extremely useful when you want to critically examine exposure. The horizontal axis represents the brightness while the vertical axis represents the number of pixels. If the graph rises as a slope from the bottom left corner of the histogram, then descends towards the bottom right corner, all the tones of the scene are captured. If the graph starts out too far in from either side of the histogram, the camera is clipping data from those areas. When the histogram is weighted towards either the left (dark) or right (bright) side of the graph, detail may be lost. If highlights are important, be sure the slope on the right reaches the bottom of the graph before it hits the right side. If darker areas are important, be sure the slope on the left reaches the bottom before it reaches the left side.

Some scenes are naturally dark or light, and most of the graph will lean to the left or right. Be careful though; dark scenes that have all the data in the left half of the histogram may be significantly underexposed, which will emphasize digital noise in your picture. You are better off increasing the exposure and darkening the image later using image-processing software.

Basic Exposure Modes

Pentax K100D series cameras are equipped with eleven different exposure modes: eight for beginners and five for more experienced photographers. Even if you are a beginner, experimenting with the more advanced exposure modes of P (Program), Tv (Shutter Priority), Av (Aperture Priority), M (Manual), and B (Bulb) will help you to understand the camera and your photography better. And the best part is, with digital, you don't waste any film! Any shots that don't work out can just be erased, and you may find that you surprise yourself with the creative shots you do come up with. The following chart outlines the basic capabilities of the five more advanced exposure modes.

Exposure Mode	Description	Exposure Compensation	Change Shutter Speed	Change Aperture
P (Program)	Automatically sets shutter speed and aperture	Yes	No	No
Tv (Shutter Priority)	Lets you set shutter speed to keep moving subjects sharp	Yes	Yes	No
Av (Aperture Priority)	Lets you set aperture to control depth-of-field	Yes	No	Yes
M (Manual)	Lets you set shutter speed and aperture to creatively capture the scene	No	Yes	Yes
B (Bulb)	Lets you capture images that require slow shutter speeds such as night scenes and fireworks	No	No	Yes

Program Mode (P)

To select Program mode, turn the mode dial until P lines up with the white index mark. In a typical shooting situation, the K100D automatically selects the suitable shutter speed and aperture depending on metering data and focal length, but you can shift exposure to satisfy your creative needs. To use exposure compensation, press the ☒**Av** button found just behind the shutter release button on the camera top, then turn the e-dial in the upper right corner of the camera back to apply up to +/- 2 stops of correction. Program mode is ideal for snapshots or candid shots and anyone who wants to make images without thinking too much about camera settings.

Hint: When using a lens with an aperture ring, set the ring to the "A" position while holding down the **AE-L/o—** button.

Shutter-Priority Mode (Tv)

Shutter-priority mode is abbreviated to Tv on the mode dial, which stands for Time Value. This mode is ideal for photographing subjects in motion, such as sports and action photography. Selecting Tv on the mode dial means that you will select the desired shutter speed and the camera will then automatically choose an aperture to match it. To use Shutter-Priority mode, turn the mode dial until Tv is lined up with the white index mark. Now you can use the e-dial on the camera back to select any desired shutter speed. The camera will select an aperture based on that shutter speed and existing lighting conditions.

Shutter-Priority mode gives you control over whether or not subject motion is sharp or blurred. When using telephoto lenses, the traditional rule of thumb is to use shutter speeds that are the equivalent of the reciprocal of the lens focal length. For example, when using a 300mm lens, 1/250 second makes a good starting point, especially with the K100D's Shake Reduction feature. For the K110, without Shake Reduction, I overcompensate and would probably select a shutter speed of 1/500 second at a focal length of 300 mm to ensure sharpness.

128

You should make sure that the available aperture range is sufficient to provide a correct exposure at the selected shutter speed. If the aperture value flashes in the viewfinder and the LCD panel, it means the selected shutter speed is too fast or too slow for an adequate exposure. Select a different shutter speed until the aperture number stops flashing or increase the ISO.

Shutter Speed and Movement

If shutter speed isn't matched to the speed of the subject, some blur will be seen in the image. The direction of motion is also important. If a person walking at an average pace is about 16 feet (about 4.88 meters) from the camera, for example, and you wish to freeze motion, use the following shutter speeds as reference points:

- 1/500 second for movement perpendicular to the optical axis
- 1/250 second for movement on a diagonal
- 1/125 second for movement parallel to the optical axis

In other words, the faster the camera-to-subject distance is changing, the faster the shutter speed you will need to freeze motion while maintaining focus. This makes sense in considering the example here; a person walking along a parallel line in front of you is going to remain at a more static camera-to-subject distance than someone who turns and walks directly towards the camera (i.e., on a perpendicular axis). No matter which direction your subject is moving in relation to the camera, the faster the subject is moving, the faster the shutter speed you will need to use to freeze motion. On the other hand, sometimes you may want to have creative motion blur in your photographs. In this case, experiment with slower shutter speeds and examine your results on the LCD monitor.

If the shutter speed isn't matched to the speed of the subject's movement, some blur will be seen in the image, even when using Continuous AF.

Aperture-Priority Mode (Av)

Aperture-priority mode is active when Av on the mode dial is lined up with the white index mark. Av stands for Aperture Value. In Av mode, you select the desired aperture using the e-dial and the camera automatically selects an appropriate shutter speed from between 1/4000 second and 30 seconds depending on the lighting conditions. The initial value that appears in the viewfinder and on the LCD panel is the last aperture used. Depth of field is an important creative tool and is partially controlled by aperture, so Aperture-Priority mode enables you to exercise control over depth of field.

Depth of Field

The basic laws of imaging state that only one part of a three-dimensional object can be truly in focus at the image plane. Even so, areas to a certain degree in front of and behind the plane of focus will also appear to be more or less in focus; there is a range of acceptable focus that is one-third in front of and two-thirds behind it the point of critical focus. That area within the range of acceptable focus is called depth of field. This is partially determined by the camera-to-subject distance, and is also greatly affected by the selected shooting aperture. Depth of field increases as the lens aperture is stopped down (a higher f/number is used) and decreases as the lens aperture gets larger (a lower f/number is used). Depth of field also increases the further that the camera is from the subject, and decreases the shorter the camera-to-subject distance becomes.

Manual Mode (M)

There are lighting situations that can confuse even the most sophisticated metering system. In times like these, your best bet may be to use Manual exposure mode by rotating the mode dial to M. Turning the e-dial by itself will adjust the shutter speed, and turning the e-dial while pressing the ⊞ Av button (located on the camera top behind the shutter release button) will adjust the aperture. As you do your adjusting, the difference in exposure between what you have selected and what the camera considers "appropriate" appears at the bottom right of the viewfinder. When 0.0 is displayed, the camera is in agreement with your exposure settings. When the difference between you choices and what the camera would choose exceeds plus or minus three stops, the indicators blink. Manual exposure mode can be especially helpful with high subject contrasts and strong backlight, but also when a specific mood is desired. In snowy conditions, for example, I add 1.5 stops and meter off the snow.

Bulb (B)

In Bulb mode, the shutter stays open as long as the shutter release is pressed. B represents Bulb on the mode dial and, when selected, "bu" appears in the viewfinder and on the

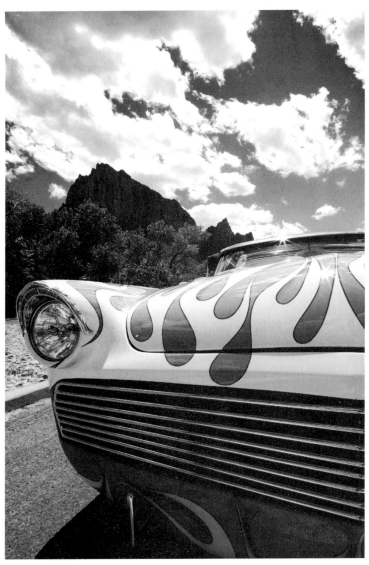

By adjusting the lens aperture, you have greater control over the photograph's depth-of-field; higher f/numbers will increase depth of field while lower f/numbers will lessen it.

LCD panel in place of a shutter speed. Time exposures using Bulb mode should only be made using a sturdy tripod, and you can reduce the risk of camera shake by tripping the shutter using the optional cable switch CS-205 or Remote Control F. If you set the ISO to AUTO, the camera will set it to ISO 200. If you haven't turned on the camera's Noise Reduction feature (see pages 105-106), it's a good idea to do that before making an exposure.

Auto Picture ⬚ᴬᵁᵀᴼ ᴾᴵᶜᵀ⬚

Auto Picture mode is the K100D's full automatic exposure mode. You can activate it by turning the mode dial until the green ⬚ᴬᵁᵀᴼ ᴾᴵᶜᵀ⬚ rectangle lines up with the white index mark on the camera body. ⬚ᴬᵁᵀᴼ ᴾᴵᶜᵀ⬚ is designed for newcomers to SLR photography; all camera functions are controlled automatically in this mode. The K100D automatically selects from Portrait, Landscape, Macro, or Moving Object modes depending on what it reads in the scene. Much like a point-and-shoot camera, all you have to do is aim the camera at the subject and click the shutter release.

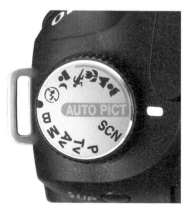

The mode dial is where you select an exposure mode to use so the camera is set to use the optimum settings for your particular subject's lighting, distance, and motion.

Portrait ♟

Portrait mode is activated when ♟ on the mode dial is aligned with the white index mark on the main camera body. One of the characteristics of a professional portrait is a focused face (specifically the eyes) placed in front of a soft,

This photograph was taken in my front yard using Pentax's superb smc P-D FA 50mm f/2.8 lens. I also use the K100D's built-in flash for fill a fill flash—always a good idea when photographing flowers on a sunny day.

out-of-focus background. In order to achieve minimal depth of field for this effect, this mode selects the largest aperture on the current lens and a fast shutter speed. If there is too much light for the fastest shutter speed, the camera will stop down the aperture. ♟ works best with fast lenses that have focal lengths of 80mm or longer.

Landscape ▲▲

Landscape mode is activated when ▲▲ on the mode dial is aligned with the white index mark. The trademarks of a traditional landscape image are wide angles of view and extremely sharp focus, which is why the K100D's ▲▲ mode is designed for short focal lengths and increased depth of field. It's the exact opposite of ♟ mode which, as we discussed, is designed for longer focal lengths and limited depth of field. ▲▲ mode increases depth of field as well as saturation and contrast.

Macro 🌷

This mode lets you take vibrant, close-up pictures of flowers and other small objects. Select it by turning the mode dial until 🌷 lines up with the white index mark. 🌷 mode works best with your zoom lens's macro setting, or even better with specialized macro lenses such as the smc P-D FA 100mm f/2.8 or the smc P-D FA 50mm f/2.8.

Moving Object 🏃

Turn the mode dial to 🏃 and you're in Moving Object mode. This mode is designed to let you make sharp photographs of quickly moving subjects, such as at a sporting event. Photographing sports can be a challenge because the subjects are in motion and the long lenses typically used for such purposes are more subject to camera shake than shorter focal length lenses. 🏃 mode is biased towards fast shutter speeds that stop motion and minimize the possibility of camera shake resulting from the use of long focal length lenses. This is especially important when using the K110D because it does not have Shake Reduction built in.

Trying to capture fast action? Use a long focal length and switch your camera to 🏃 mode. © John Clifford.

Night Scene Portrait ♦♣

Just as with the other exposure modes, select Night Scene Portrait mode by turning the mode dial until ♦♣ is lined up with the white index mark. ♦♣ mode is designed for taking pictures of people at night. It involves using the camera's built-in flash to illuminate the subject while a slow sync shutter speed provides detail and color in the background. If you were to just snap off a portrait of someone in front of a cityscape or sunset in [AUTO PICT] mode, for example, it's likely that the foreground would be exposed correctly, but the background lighting and details would probably be lost. ♦♣ mode, on the other hand, automatically selects a long exposure time so the background will have sufficient exposure. The flash will accurately illuminate the main subject in the foreground, and the background will be properly exposed by the lengthened exposure time.

Flash Off ⊕

In ⊕ mode, the built-in flash is deactivated. All other camera settings respond as though you have selected [AUTO PICT] mode. As with the other exposure mode selections, access ⊕ mode by turning the mode dial until ⊕ is lined up with the white index mark.

Scene SCN

This mode is actually a subset of exposure modes that lets you select from eight different options depending on the shooting conditions. To choose from these options, turn the mode dial until **SCN** is lined up with the white index mark, then press the **Fn** button. Next, press the **OK** button and the Mode Palette appears. Use the four-way control to navigate through your options and choose a specific scene mode. Press the **OK** button again and you're ready to shoot. Your Scene mode options are:

Night Scene 🏙 : Use this setting for night photography such as illuminated building and holiday lights. To get the sharpest possible results, use a tripod and be sure to turn off the camera's Shake Reduction feature.

136

Surf & Snow 🏖 : Where night scenes fool metering systems with point of light and lots of darkness, beach and snow does just the opposite, giving you lots of light and making the built-in meter want to underexpose the shot. Choosing the 🏖 mode tells the camera what it's up against and produces well-exposed images in these situations.

Text 🅰 : Do you need to photograph documents or do other copy work? This mode is ideal for such situations, and will optimize camera controls to make text appear sharp and clear.

Sunset 🌅 : Sunsets and sunrises are notoriously difficult to shoot because you have lots of dark areas and a brilliant light source in the same frame. Using 🌅 mode sets up the camera to deal with these unique circumstances and produces the beautiful colors that you see with your eyes that have historically been difficult to capture in a photograph.

Kids 😊 : This mode is optimized to capture candid photographs of kids who may not want to sit still for a portrait. It also tells optimizes camera settings to produce healthy and bright skin tones.

Pet 🐾 : Kids aren't the only subjects that are hard to photograph; so are pets! If you want to photograph your animals, this is the mode to use. And if you can believe it, when you select this mode, you also get additional choice of telling the camera whether you are photographing a cat or a dog. Use the e-dial to select the animal type.

Candlelight 🕯 : This scene mode kicks up the ISO speed and turns off the flash. The result is a nice warm looking shot made by candlelight, with the candles providing the main source of illumination. Keep in mind, though, that it does not change the camera's white balance.

Museum 🏛 : Most museums don't allow flash photography, so this mode disables the camera's built-in flash. Here's your chance to maximize the K100D's Shake Reduction feature to ensure sharp pictures. Users of K110D cameras will have to practice holding the camera steady.

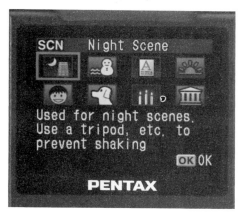

To access any of the Scene mode options, turn the mode dial to **SCN**, press the **Fn** button, then press the **OK** button and the Mode Palette appears. Use the four-way control to choose a specific Scene mode selection.

AE Lock

At the very moment you press the **AE-L/o–** button on the right hand corner of the camera back, the camera locks the current exposure settings. While exposure is locked, ✱ will appear in the viewfinder. Exposure will remain locked as long as the **AE-L/o–** button is pressed or the shutter release button is held halfway down; specific aperture and shutter speed values may change, but exposure will remain locked. AE lock is not possible if you are using M or B shooting modes. If you wish, you can also set up the camera to lock exposure when focus is locked by using the [AE-L with AF locked] selection in the Custom Setting menu (see page 107).

⟵ *Going to the beach? Try some shots in ⚖ mode to see the difference that it makes in your exposures. © Hisashi Tatamiya*

The **AE-L/o–** *button allows you to take an exposure reading on a specific subject, then recompose the picture and the locked-in meter reading will not change.*

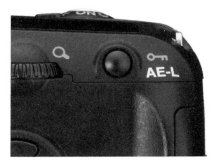

Exposure Compensation

This is my favorite feature of the K100D series cameras, and one that I constantly use to improve my images. After I make an exposure, I examine the image on the LCD monitor and check its histogram (see page 126); if I don't like it, I'll make another exposure using the exposure compensation feature to adjust for the over- or underexposure I perceived.

To set exposure compensation, press the **☒Av** button and rotate the e-dial. As you do, the amount of compensation will be displayed in the viewfinder. You can adjust compensation from minus two to plus two stops in increments of one-half or one-third stop, depending on what you have set for the [Exposure Setting Steps] feature in the Custom Setting menu (see page 106).

Note: Unlike some other cameras, turning the camera off or changing to another exposure mode does not cancel exposure compensation in the K100D series cameras. You must rotate the e-dial until zero compensation is noted in the viewfinder.

Autoexposure Bracketing

Bracketing is a time-honored technique left over from film that involves making a sequence of exposures that include the initial metered exposure plus one each of an over- and underexposed image. The Pentax K100D is equipped with an

Auto Bracket function for exactly this purpose. The first frame is exposed with no compensation, the second is underexposed, and the third is overexposed.

Note: The Auto Bracket function is not available when the exposure mode is set to B (Bulb).

To access the Auto Bracket function, press the **Fn** button and use the four-way controller scroll over to ![bracket icon]. Press the **OK** button, then press the **Fn** button again and the ![bracket icon] icon will appear in the LCD panel to let you know who are in Auto Bracket mode. When you release the shutter, a sequence of three shots will be made. You can change the order of the bracketing sequence by going to the [Auto Bracket] feature in the ![camera icon] Rec. Mode menu (see pages 88-89). If you wish to change the exposure value steps between each shot, go to the [Expsr Setting Steps] feature of the Custom Setting menu (see page 106).

In tricky lighting situations, you can combine exposure compensation with the Auto Bracket function. You can shift the entire series of bracketed frames so that, for example, backlit scenes are only bracketed on the plus side. Here's how it works when combining an Auto Bracket interval of one-half stop with an exposure compensation of plus one stop:

- **First frame** = plus one stop
- **Second frame** = plus one-half stop
- **Third frame** = plus one and one half stops

Exposure bracketing should not be confused with the kind of uncertainty where an inexperienced photographer takes many shots in the hope of getting just one of them right. Sometimes bracketing is the only available option, even to professionals. Remember that Auto Bracket will reset when you turn the camera off, but exposure compensation will not; it needs to be manually reset to zero.

Lenses and Accessories

Let's begin our lens discussion by going over some facts and terminology. The Pentax K lens mount is a precise mechanical device that couples the lens to the camera ensuring that the optical axis is always horizontal to the sensor plane, even after years of use. The diaphragm is a mechanical shutter arrangement consisting of multiple blades that limit the amount of light passing through the lens. The helicoid is a precision rotating cylinder with multiple threads that move elements and groups of elements to achieve focus. The lens barrel is a hollow metal or plastic cylinder where the lens elements are positioned and accurately centered.

Minimum focusing distance and maximum magnification ratio are important for close-up and macro photography, as well as for full-length portraits and detail shots. Minimum aperture can be used to calculate the maximum depth of field for a given magnification ratio. Filter diameter is also important to be aware of when purchasing filters or other screw-on attachments for your lens. (See pages 155-158 for more about filters.) Other information such as overall lens length, maximum diameter, and weight can be important for travel, nature, or landscape photography, and is certainly of interest to photographers who have to carry their equipment for any length of time or store it in limited space.

The substantial array of Pentax lenses, both old and new, that can be used with the K100D series cameras will allow you the versatility to shoot a wide variety of subject matter. © Haley Pritchard

Interchangeable lenses offer far more versatility than the non-removable lenses of a point-and-shoot camera. You can use macro lenses to get up close, or you can shoot from a distance and capture details with a telephoto lens. © Hisashi Tatamiya

Pentax offers an extensive lineup of both manual and autofocus wide-angle, standard, zoom, telephoto, macro, and special purpose lenses. Along with the DA series that is exclusively designed for digital cameras, all current 35mm Pentax lenses are compatible with the K100D series digital SLR (D-SLR) cameras. Pentax also provides a full array of converters and adapters to extend lens versatility and performance.

In general, you can use Pentax DA, D FA, and FA J lenses, as well as any Pentax lens that has an Aperture A (Auto) position with the K100D series cameras. All camera exposure modes are available when these kinds of lenses are used. To permit shutter release with lenses of types other than those listed above, use the [Using aperture ring] feature in the Custom Setting menu, which lets you enable shutter release when the lens aperture ring is set to something other than "A." (See page 109 for details on this Custom Setting menu feature.)

Lenses that can be used with the Pentax K100D series

Function	DA/D FA/ FA J/ FA (KAF, KAF2)	F lens (KAF2)	A Lens (KA)
Autofocus (lens only) with AF adapter	Yes	Yes	Yes
Manual Focus (with focus indicator)	Yes	Yes	Yes
Eleven AF Points	Yes	Yes	No
Power Zoom	No	-	-
Aperture Priority AE	Yes	Yes	Yes
Shutter Priority AE	Yes	Yes	Yes
Manual Exposure	Yes	Yes	Yes
P-TTL Flash	Yes	Yes	Yes
Multi (16 segment) Metering	Yes	Yes	Yes
Acquire lens focal length automatically when using Shake Reduction	Yes	Yes	No

Zoom vs. Prime Lenses

For years, the buzz from people "in the know" was that zoom lenses just weren't as sharp as prime (single focal length) lenses. That advice is a thing of the past. Today, you can get superb image quality from zoom lenses. There are,

The Pentax smc P-DA J 16-45mm f/4.0 ED/AL lens features a 3x zoom ratio, with focal lengths covering ultra-wide angle to normal ranges. It incorporates a high-refraction extra low dispersion (ED) glass element to produce a high-resolution, high-contrast image with true-to-life color rendition. It also includes aspherical lens elements to transmit the light more efficiently through the lens to the focal plane.

however, some important distinctions to be made between zoom and prime lenses, the biggest being their maximum lens apertures.

Zoom lenses are rarely as fast as single-focal-length lenses. The smc P-DA 50-200mm ED has a maximum variable aperture of f/4 – f/5.6. (A variable aperture lens has different maximum apertures at different focal lengths.) The smc P-FA 200mm (IF) single-focal-length lens, on the other hand, has a maximum aperture of f/2.8. When zoom lenses come close to a single-focal-length lens in maximum aperture, such as in this comparison, the zoom lens is usually considerably bigger and more expensive than the single-focal-length lens. Even so, zoom lenses offer a whole range of focal lengths, which a single-focal-length lens cannot do, so there's no question that zooms are not only more versatile but take up less camera bag space than a series of lenses covering those same focal lengths.

DA-Series Lenses

The DA series of interchangeable lenses are designed exclusively for use with Pentax D-SLR cameras, including the K100D series. The image circle in the DA-series lenses is designed to match up with the .93 x .62 inches (23.5 x 15.7 mm) CCD used in Pentax D-SLRs and optimizes the optical performance of these cameras. The design of these lenses also contributes to a drastic reduction in size, weight, and production cost when compared to their 35mm-format counterparts with similar specifications.

The Pentax DA 21mm f/3.2 AL measures only one inch in length and weighs 4.9 ounces (about 139 grams). Mounted on a K100D series camera, the lens protrudes very little from the camera's front.

FA-Series Lenses

The Pentax series FA lenses are primarily designed to work with the Pentax autofocus film SLR (KAF2 or KAF2-mount) cameras, making autofocus possible but are fully compatible with K100D series digital cameras. Be careful not to damage or dirty the lens information contacts and AF coupler on the mount surfaces of the camera and lens. Otherwise, failure or malfunction may result. If this occurs, wipe them gently with a clean, dry cloth.

More about Lens Mounts

In 1987, Pentax introduced the original KAF bayonet mount for the SF-series cameras, featuring an AF coupling between body and lens. A contact point on the mount transmits information (focal length, aperture, and lens dimensions) from a chip in the lens to the camera's CPU. With the launch of the Pentax PZ-series cameras in 1991, the company introduced the KAF2 bayonet, featuring power zoom and additional data transmission including MTF (Modulation Transfer Function) curve data. FA prime (non-zoom) lenses and DA, D FA, FA J, and F lenses use the KAF mount. FA power zoom lenses use the KAF2 mount. (Lenses without power zoom use the KAF mount.)

A-Series Lenses

The Pentax A series is a line of manual focus lenses that feature an automatic setting on the aperture ring. Cameras with multi-segment metering need to know the minimum and maximum aperture of the lens being used, which is achieved with a series of seven contacts in the lower left-hand section of the lens mount. One of the contacts transmits data from autofocus lenses, another tells the camera if the lens is set to "A" for Shutter Priority mode or Programmed Autoexposure mode. The other five contacts transmit aperture data for multi-segment metering. On A series lenses, there are plastic insulators in one or more of the positions corresponding to these five contacts.

Vintage and Classic K-Mount Lenses

One of the big deals about K100D series digital cameras is their ability to use every K-mount lens ever made. How many lenses is that? Pentax's Ned Bunnell told me, "Pentax has manufactured over 24 million lenses in the last five decades because we believe that for every assignment there needs to be a lens that matches each photographer's style, amateur and professional alike." Got that? 24,000,000 lenses, and that doesn't include K-mount lenses from other manufacturers.

I captured this locomotive with the K100D and a Pentax 12-24mm zoom lens at the Colorado Railroad Museum.

In 1975, another important change took place in Pentax's camera design. Asahi Optical Company (the Pentax camera manufacturer) was aware of limitations of retaining the 42 mm screw thread lens mount, so they introduced three new camera models. They all featured a new, wider lens mount that was called "K-bayonet," aka the K-mount. All earlier lenses and attachments, such as bellows units etc., could be used on the new bodies by means of an adaptor ring. To use old K-Mount lenses on your K100D series camera, here's all you have to do:

Step 1: Set the <FI with S lens used> Custom Setting menu feature to <Available>. There are two choices: <Unavailable> or <Available>. <Available> means that when an older K-mount lens is attached, the focus indicator in the viewfinder will function.

Step 2: Set the [Using aperture ring] Custom Setting menu function to [Permitted]. When the [Permitted] option is selected, pictures can be made when the aperture ring is set to something other than "A." If [Prohibited] is selected, photographs cannot be made when the aperture ring is in any position other than "A." (See page 109 for more details.)

Step 3: Once these settings are made, the Shake Reduction function is accessible to you and you can input the lens' focal length. If it is an older lens without the "A" setting on the aperture ring, you can only use Manual mode (set the M position on the mode dial) or Shutter Priority mode (mode dial set to anything but M).

Independent Lens Brands

Independent lens manufacturers, such as Sigma and Tamron, make excellent lenses that fit the K100D series cameras. Some of these third-party lenses include low-dispersion glass

Tamron has two series of lenses aimed specially at users of D-SLRs. Digitally Integrated Design (aka Di) is the designation they use for lenses designed for use with D-SLR cameras, and they feature optics optimized to meet the performance characteristics of D-SLRs. Tamron's Di-II lenses are designed for use with image sensors that are 24 x 16 mm (.94 x .63 inches) or smaller, and are not compatible with 35mm film cameras or digital SLR cameras with larger sensors.

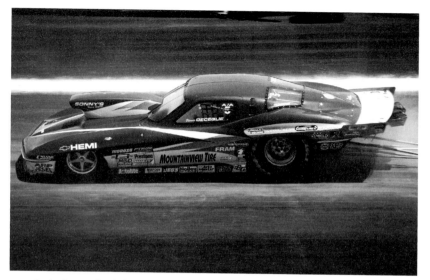

I photographed this drag racer using Tamron's AF 18-200mm f/3.5-6.3 XR Di II lens on the K100D.

and are extremely sharp. Others may not match the best Pentax brand lenses, but still offer features (such as focal length range) at a price that makes them worth considering. To a degree, you do get what you pay for. A low-priced Pentax lens compared to a low-priced independent brand lens probably won't be much different. On the other hand, the high level of engineering and construction found on a Pentax lens can be difficult to match.

Caring for Your Lens
Leaving the camera in direct sunlight without covering the lens with the lens cap may damage to the inside of the camera. When storing the lens in a case, attach the front and rear lens caps that come supplied with the lens to protect it from dust and scratches. Moisture can cause serious damage to optical glass elements. Keep you lens in as dry a place as possible. Storage in a damp place may cause mildew, so avoid storing the lens in a place where temperature and humidity are high.

Macro and Close-Up Lenses

Close-up photographs can be easy and fun to shoot. Close-focusing zoom lenses with macro capabilities allow you to focus up-close without accessories, although focal-length choices may be limited when using a zoom lenses macro feature. It is also important to note that even though these zoom lenses tout a "macro" setting, it is really just a close-focus setting and not a true macro. The classical definition of macro photography is that in which the captured image is as large or larger than the actual size of the subject. With 35mm film cameras, you should have the ability to focus on an area at least as small as 24 x 36 mm (.94 x 1.42 inches). For the K100D series cameras' 23.5 x 15.7 mm sensor size (.93 x .62 inches), the lens has to get even closer to achieve a true magnification of 1:1. Though relatively expensive, macro lenses such as the smc P-FA 100mm f/2.8 that achieve a magnification of 1:1 with 35mm film are designed for superb sharpness at all distances and will focus from mere inches to infinity. In addition, they are typically very sharp at all f/stops.

Cokin, Hoya, Tiffen, and Sunpak, as well as several camera manufacturers, offer what are typically called close-up "filters." Although they are not filters in the traditional sense, they look like filters and work like filters. These close-up "filters" are really supplementary lenses that use high-quality magnifying optics to shorten your camera lens' close-focusing distance, allowing the lens to get closer to the subject and achieve a larger image scale. Close-up lenses are usually available in three different strengths, such as Tiffen's Close-up +1, Close-up +2, and Close-up +3 lenses. They are double-threaded so that they may be used in combination with each other; if you go this route, it is a good idea to place the strongest filter closest to the camera lens for the sharpest results.

Do you want to get even closer? The next step up the macro-focusing ladder is to use an extension tube with your camera lens. An extension tube provides additional separa-

A Macro lens such as Pentax's smc P-FA 50mm f/2.8 that will produce 1:1 magnification with 35mm format was used here to capture a close-up of some hardware on a locomotive at the Colorado Railroad Museum.

tion between your lens and the sensor. You might think of it as an alternative to the more complex (and more expensive) extension bellows that many camera manufacturers offer as a close-up accessory. A typical extension tube set includes three tubes of different lengths—such as 31 mm (1.2 inches), 21 mm (.83 inches), and 13 mm (.51 inches)—that can be used separately or in combination with each other to obtain larger or smaller magnifications. These tubes will function with the K100D series cameras' TTL metering and focus mechanisms to provide full autofocusing capability.

Sharpness

Sharpness is not just a matter of buying a well-designed macro lens. The other close-up options can also give superbly sharp images. Sharpness problems in close-up photographs almost always result from limited depth of field, incorrect focus placement, and camera movement. The closer you get

to a subject, the shallower depth of field becomes. You can stop your lens down as far as it will go (i.e., use the smallest f/number) to get more depth of field, or try using a wider angle, but depth of field will still be limited at these short distances. Because of this, focus is critical. If only half of the flower petals are in focus, the overall photo will not look sharp. Autofocus can be a real problem with critical focus because the camera will often focus on the wrong part of the photo. You might want to try using manual focus by focusing the lens at a reasonable distance then moving the camera toward and away from the subject, watching it go in and out of focus. You should also bear in mind that, when making close-up photographs, even slight movement can shift the camera in relationship to the subject and throw the image out of focus. To help avoid this issue, use a high shutter speed and/or mount the camera on a tripod.

Close-Up Photography Tips

The best looking close-up images will often be ones that allow the subject to contrast with its background, making it stand out and adding drama to the photograph. Here are a few tips:

- Look for a background that is darker or lighter than your subject. This might mean a small adjustment in camera position.
- Backlighting is also an excellent technique to try, as it produces bright edges on your subject with lots of dark shadows behind it.
- Color contrast will also make your subject stand out from the background. Try to shoot your subject from an angle where the colors in the background are starkly different from those of the subject.
- One of the best close-up techniques is to work with the inherent limit in depth of field and deliberately set a sharp subject against an out-of-focus background or foreground. Experiment with different apertures, then check your results in the LCD monitor.

The K100D's built-in flash was used in this photograph to add some "snap" to the close-up image.

Analog Filters in a Digital World

Many people assume that filters aren't needed for digital photography because adjustments for color and light can be made later in the computer. To the contrary, filters can save a substantial amount of work in the digital darkroom by allowing you to capture the desired color and tonalities for your image right from the start. Here are a few reasons for using camera filters:

- When working under difficult environmental conditions, such as blowing dust or sand, a Skylight or UV filter will protect the front element of your expensive lens from damage.
- Colored filters can enhance images in various ways, such as by darkening skies or lightening foliage, for example.

155

Camera filters are available in different shapes, sizes, and materials, including delicate gelatin filters that drop into holders or lens hoods, glass filters that screw onto your lenses, and rectangular filters that fit into modular holders. Photo courtesy of Tiffen.

- Some digital cameras produce pale skin tones when making portraits. This can be corrected by using an 81A warming filter to help make skin tone look more natural.
- Graduated neutral density filters let you control areas of excessive brightness, such as the sky, helping to bring the overall exposure in the rest of a scene into balance and possibly adding a bit of color at the same time.
- Special effects filters, such as star or prism filters, let you capture unique and intriguing images using special "distorting" effects.
- Using infrared filters with your K100D series camera will allow you to make images of everything from landscapes to lily pads appear more dramatic.

For this image, I used a Singh-Ray I-Ray infrared filter on my K100D, then processed the image file in Adobe Photoshop to produce this final result. ⇨

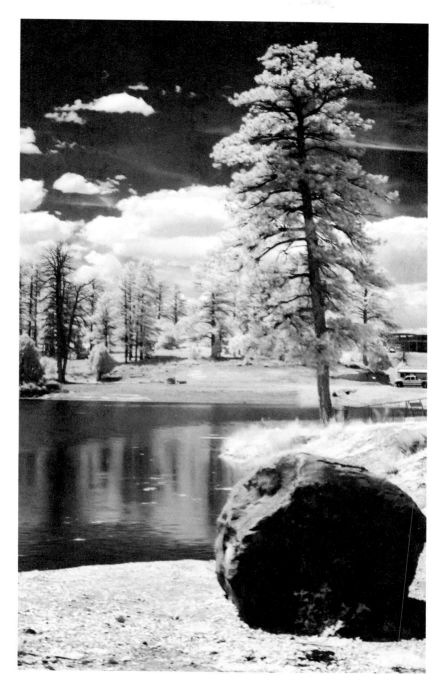

If you're new to photography or new to filters, here's a highly opinionated list of filters I think should be in every photographer's toolkit:

Skylight, UV, or Haze Filters: While not everybody agrees with the concept, many photographers place a UV or Skylight filter on every lens they own. I find a Haze or Skylight (1A) filter provides extra protection when shooting outdoors in environmentally unfriendly situations. In addition to protecting the front element of your lens, a Skylight filter absorbs UV light and provides a slight warming effect. Haze filters are designed to reduce the blue haze that can be caused by ultraviolet light. A good quality Skylight filter will absorb 45.5% of the UV light present, but a Haze filter provides 71% absorption. Photographers who live at high altitudes or shoot marine scenes may want to use a Haze 2 filter that absorbs virtually all UV light.

Circular Polarizer: A Polarizing filter can deepen the intensity of blue skies, as well as reduce or eliminate glare from non-metallic objects. Many manufacturers now offer Warm Polarizers, including the famous Moose Filter (www.moose395.net), which combines a Polarizing filter and a warming filter. Polarizers are available in linear or circular versions, but your K100D series camera requires a Circular Polarizer filter. A Linear Polarizer will not function properly with the camera's autofocus system.

Neutral Density (ND) Filter: Since the lowest ISO speed for the K100D is ISO 200, Neutral Density filters are an indispensable part of my filter toolkit. ND filters are available in various densities to absorb one, two, or three stops of light. They are useful when you want to photograph something at slow shutter speeds (or wide apertures) and your digital camera does not offer a low enough ISO setting.

Tripods and Camera Support

Tripods come in many sizes, from tiny tabletop models to heavy-duty camera stands for studio use. Because of the many types, sizes, styles, and even colors, there's never a "one size fits all" solution. That's why most of us end up with collections of camera supports; we use different tripods for different kinds of photographic tasks. Using a tripod enforces a deliberate approach to making photographs. Having to think about composition before banging off a few frames will improve the quality of your images more than you might imagine. And in my opinion, a tripod is also the sign of a serious photographer; people extend more respect, in my experience, when they see a photographer with a tripod.

Gitzo's Mountaineer Reporter is part of a new family of Carbon 6X tripods that reduces overall weight by up to 17%.

Some applications demand a tripod. For close-up work, a tripod is a necessity; the use of small apertures for macro work must be compensated with slower shutter speeds, which demands camera stability. At the other end of the

spectrum, long focal length lenses for sports or wildlife photography require a tripod—sometimes two! Depending on the size of the lens, you may need a separate tripod to support it.

There are just a few basics for a good tripod. For one, it must be sturdy but lightweight enough so that you'll use it! After that, it becomes a matter of matching the tripod to your way of working. The kind of camera you use affects the type of tripod that's right for you. When I realized I could hold a camera steadier than my first tripod, I threw it out. The head wore out because I ignored the first question you should ask yourself: What kind of camera am I going to use with this tripod? I'd been using a medium format camera on a tripod that would have given me better service with a 35mm or digital SLR. The weight of the camera was too much for the head and it wore out.

Some manufacturers offer a choice of leg and head types, allowing you mix and match. You may even want to use one manufacturer's head on another company's legs. There are two types of heads—ball or pan—with variations in between. Ball-head aficionados tell you their favorite is quick, easy to use, and you don't have to turn different levers to move it where you want. Pan head folks say it's easier to level the camera or follow movement. Try both and pick the one you like.

Camera stores tell me they sell an even number of ball versus pan heads. Make sure the head is appropriate for the camera. The larger the platform, the more securely the camera can be seated and balanced. A larger head also provides space for positive locking mechanisms. Ball heads are compact and feature a knob or lever that locks and unlocks the ball mounted under the camera platform. By unlocking the ball, you can move the camera freely in any direction. Pan heads have one lever that locks and unlocks to move the head from side to side and another for moving it up and down. You can lock both for firm camera placement, or just lock one and pan the camera using the other.

A good tripod protects the investment you've made in expensive optics by delivering the best possible photographs. Good tripods aren't cheap, but that doesn't mean there aren't some bargains. Since 90% of the sales of top-of-the-line tripods are to photographers unsatisfied with their old tripod, check the tripod's construction carefully before buying. You want a tripod that will give years of service and improve your photography at the same time.

Monopods

There are some situations where you can't carry a tripod, or there's no space to use one. That's where a monopod comes in handy. If you're shooting sports, a monopod is useful for working with long lenses in tight spaces. If you're photographing from the stands, a tripod will interfere with the other spectators, but a monopod won't. For the photographer with limited space and equipment weight issues—like backpackers—monopods are ideal. The weight is one-third of a tripod of similar quality. Monopods can be used with the same type of heads that tripod use, but are typically used without any head. The 1/4 inch threaded bolt sticking out from the top of the monopod can be screwed into the bottom of your camera or the tripod collar included with long focal length lenses and can easily be moved to get "that perfect angle." While not as steady or rigid as a tripod, they are still a good alternative to hand holding with a long lens, slow shutter speeds, or both. While shopping for a monopod, remember that the same standards that apply to a good tripod also apply to the monopod. One benefit is that because of the simplicity, even a top of the line monopod is surprisingly affordable.

Hint: Pentax recommends that you turn the K100D's Shake Reduction off when using a tripod, but it recommends that you turn it on when using a monopod. The reason for this is that there is still some movement or possibility of movement, however slight, with a monopod.

Flash

The most important characteristic of electronic flash for photography is the quality and the quantity of the light it can produce. Other things, like recycling time, power control, and the ability to accept accessories, are important too, but it all boils down to quality and quantity.

The K100D series' flash system eliminates the guesswork in your flash photography, and because the LCD monitor provides instantaneous feedback, you know immediately whether the flash exposure is correct or not. You can then adjust the ambient or flash light level higher or lower, change the camera angle, soften the light, color it, and much more.

Guide Numbers

When shopping for a flash unit, it's helpful to compare guide numbers in order to evaluate the quantity of light emitted. A guide number (GN) is a simple way of stating a flash unit's power. It's computed as the product of aperture value and subject distance, and is usually included in the manufacturer's specifications for the unit. Higher guide numbers indicate more power, however this is not a linear relationship. Guide numbers, because they are directly related, act like f/stops (for example, 56 is half the power of 80, and 110 is twice the power of 80). Since guide numbers are expressed in feet/meters, distance is part of the guide number formula. When dividing the GN by the distance, you'll get the aperture required for proper exposure. Conversely, if you divide the GN by the aperture number,

I made this portrait of Tia in my kitchen with the K100D in Program mode using the 12-24mm SMC Pentax lens.

you get the distance at which you should place the subject. Guide numbers are usually based on ISO 100 film but this can vary (the K100 has a minimum of ISO 200) so check the ISO speed reference when comparing guide numbers for different units. If the flashes you are comparing have zoom-head diffusers, be sure to compare the guide numbers for similar settings.

Using the Built-in Flash

When should you use the built-in flash? The most obvious answer is when light is low and you need to illuminate your subject, but that may not always be the best way. If light levels are low and you use the built-in flash you may get an overexposed foreground and an underexposed background. The key to using your built-in flash is in knowing when use it. If there's any secret at all to knowing when the "right" time is, it's learning how to see the light falling on your subject, especially the range of shadows and highlights within the scene. Learning to see light is not difficult, but takes a bit of practice and using the K100D's LCD monitor will help you instantly analyze the quality of those flash photographs after you've made them.

Caution: *When using the built-in flash, remove the lens hood if you are using one. The lens hood will block a substantial amount of light from the built-in flash.*

The K100D's built-in flash has four modes, accessible by pressing the Fn button **Fn** , and using the down button ⬇ in the four-way controller to display the Flash options menu on the LCD screen.

⚡ **Auto:** The camera automatically reads the surrounding light. The built-in flash pops up and discharges automatically when necessary, such as when using a slower shutter speed that would show camera shake, or in backlit conditions. (The flash may pop up but won't fire if the camera determines it isn't necessary.)

164

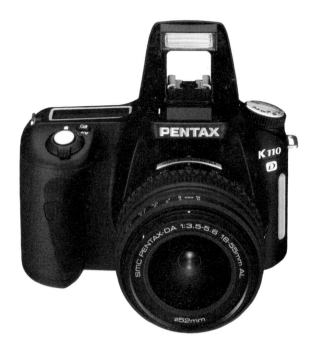

The built-in flash in the K100D has a guide number of 15.6 meters (51.2 ft.) at ISO 200 and coverage wide enough for an 18mm lens. The flash synchronization speed is 1/180 second and slower.

Manual discharge: The flash fires when it is popped up. This setting gives the control to the photographer. To activate the flash, press the Flash UP button **4UP** to the left of the viewfinder.

Auto Flash + Red-eye Reduction: This mode lights up a "red-eye reduction" light (which causes the subject's pupil to constrict, minimizing or eliminating red eye) before the flash fires automatically.

Manual Flash + Red-eye Reduction: Discharges flash manually and projects the red-eye reduction light on the subject before the manual flash.

When the ↯UP is pressed, Manual discharge mode is used regardless of what flash mode has already been selected.

Hint: The shutter cannot be released until the built-in flash has recycled. If this bugs you, you can change the default setting by using a custom setting [Release When Charging] to enable shutter release before the built-in flash is ready. If you enable this function, remember that the flash will not fire until it has fully recycled, but the shutter will still release.

When photographing static subject matter, sometimes the best way to get a properly exposed photograph is not to use flash at all and instead place your camera on a tripod and use the available light. If you don't own a tripod, an alternative is to kick up the camera's ISO setting until digital noise in the photograph looks like grapefruits, so the next choice is flash.

Using a camera's built-in flash as the sole source of lighting for indoor people pictures will produce a photograph, but the lighting may be flat and contrasty. Nevertheless, the small flashes found in digital SLRS (D-SLRs), such as K100D series cameras, do a surprisingly good job in delivering well-exposed pictures—if you don't exceed its maximum range.

For this photo, I wanted to lend motion to the image while illuminating it so I hand held the camera and used the built-in flash with a slow shutter speed. © Haley Pritchard ⇨

This portrait of Jamie Lynn was made in the shade with the white balance set in Auto mode and no flash. While the backlighting is nice, the AWB still produced an underexposed and slightly blue look, and JL's sparkling eyes aren't sparkling without light to illuminate them.

A much better way to use your built-in flash indoors is when there's some ambient light to fill in the darker shadows. This technique separates your subject from the background and focuses the viewer's attention on the subject. In fact, when you have too much ambient light indoors, flash is the best way to control contrast and add dimension to the photograph. Without flash, you may only get a silhouette.

If you want to increase or decrease the amount of light from the built-in flash, use the [Flash Exp Comp] setting found in the Record Menu. When selected, it will let you adjust the flash output by -2.0 to +1.0 f/stops in one-half or one-third increments, depending on your [Expsr Setting Steps] custom setting. When flash compensation is being used, the Exposure Compensation icon blinks in the viewfinder. This compensation setting also works with external units that support the camera's P-TTL (Pentax Through-the-Lens) flash mode.

The built-in flash was popped up for this shot, providing not just fill light but also extra warmth, which the AWB used to warm up the entire photograph although it's hard to see in black and white.

When making pictures during the day, (especially in the harsh light of the early afternoon sun) turning your built-in flash on is one of the simplest ways to improve your photographs. Instead of getting underexposed pictures, harsh shadows, or silhouettes, your subject pops out against the background.

What's the secret of good fill flash outdoors? Basic photo books are full of rules to follow that help you obtain the mathematically correct ratios of daylight-to-flash, but I feel only you know what looks best. Take the time to do some testing. Shoot some exposures with your D-SLR at all the flash's automatic settings or bracket by changing the camera's exposure compensation dial.

LumiQuest's Soft Screen is specifically designed for the built-in flashes found on D-SLRs. It softens hard shadows and reduces hot spots that produce the familiar "flash on camera look." The screen folds flat to approximately 4 x 4 inches for easy storage. It attaches to the front "name plate" of your camera but some recent D-SLR models have smaller plates so LumiQuest includes tiny Velcro fasteners to solve the problem. (www.lumiquest.com)

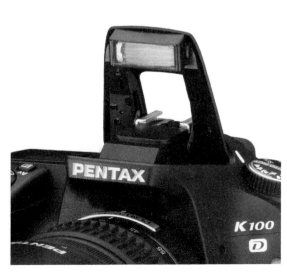

Using an optional external flash, such as the AF540FGZ or AF360FGZ, enables a variety of flash modes, including P-TTL auto flash, high-speed flash synch, and wireless mode. See the chart below for details.

Flash Metering

The built-in flash, as well as new external speedlights from Pentax, uses the company's P-TTL Metering system. In P-TTL mode, the flash fires a pre-flash burst before the actual exposure. In conjunction with the camera's multi-segment light sensor, the flash meter measures subject distance, brightness, and backlit conditions. The resulting data is calculated and adjusted for the correct flash output. For the built-in or external flash, P-TTL is available when using Pentax DA, D FA, FA J, F, or A lenses.

Using an Optional External Flash

	Built-in Flash	AF540FGZ or AF360FGZ
Red-eye reduction	Yes	Yes
Automatic Flash	Yes	Yes
After the flash is discharged, the camera automatically switches to the flash sync (1/180 sec) speed	Yes	Yes
Auto check in viewfinder	No	No
P-TTL auto flash	Yes	Yes
Slow Speed Synch	Yes	Yes
Flash Exposure Compensation	Yes	Yes
AF Illuminator	Yes	Yes
Rear Curtain synch flash	No	Yes
Contrast control-synch flash	No	Yes
Slave Flash	No	Yes
Multiple Flash	No	No
High Speed flash synch	No	Yes
Wireless Flash	No	Yes

Flash with Camera Exposure Modes

Auto Picture [AUTO PICT]

In Auto Pict you have no control over how and when the flash is used. The camera—not the user—determines the exposure and when to pop up and fire the built-in flash. If you move into the creative modes that give you control over what the image looks like, you also gain control over the flash. The built-in flash cannot be controlled or fully fired when Pentax pre-A series lenses or soft-focus lenses are used.

Program (P)

In this mode, flash photography can be used for any photographic situation where supplementary lighting is needed. All you have to do is turn on the flash unit and the camera does the rest automatically. When using an external speedlight such as the AF540FGZ or AF360FGZ, set it in P-TTL mode.

Shutter Priority (Tv)

This mode is a good choice for situations where you want to control the shutter speed when using the flash. The K100D will synchronize with the flash with all shutter speeds below 1/180. The aperture value will automatically change according to the ambient light. (When lenses other than DA, D FA, FA J, FA, or A are mounted, the shutter speed is fixed at 1/180 second.) You can use the flash in this mode when you want to change the effect of a moving subject.

Aperture Priority (Av)

Using this mode you can balance the flash with the existing light and it allows you to control the depth-of-field as well. By setting the aperture, you also affect the range of the flash. Once you set the aperture, the camera automatically picks the correct shutter speed for the lighting conditions. The selected shutter speed depends on the focal length of the lens being used. When lenses other than DA, D FA, FA J, FA, or A are mounted, the shutter speed is automatically set at 1/180 second.

Manual Exposure (M)

Using this mode gives the largest number of options. This can be a good or a bad thing, depending on your experience level. You can select any aperture or any shutter speed below 1/180 sec. Manual mode opens a wide range of creative possibilities, including the ability to take photographs of subjects in motion that have a sharp core subject surrounded by indistinct outlines.

Red-Eye Reduction

More flash photos of people or pets are ruined by red-eye than any other photographic problem. This unsightly effect occurs with low flash angles, such as with a built-in flash that points directly at the subject. The retina of the eye reflects light directly back to the camera lens, causing pupils to appear red in the photograph. K100D series cameras are equipped with a red-eye reduction feature that is designed to decrease this effect, but here are a few other ways to reduce red-eye:

- Ask the subject not to look directly at the lens
- Turn up the room lights, which will cause the iris in the eye to constrict.
- Use shoe-mounted accessory units, such as the AF540FGZ. These sit taller on the camera body, and have a larger flash-to-lens axis angle which helps to eliminate red-eye problems.

Pentax Speedlite Flash Units

Pentax's AF540FGZ auto flash unit features a large guide number of 54 (at ISO 100.) This slip-on, twist/tilt, auto-zoom flash provides a variety of advanced flash applications, including P-TTL auto flash, high-speed synchronization, and wireless P-TTL auto flash. When mounted on a Pentax D-SLR equipped with an FA, FA J, DF A or DA series lens, the AF540FGZ automatically adjusts its angle of discharge to

When mounted on a Pentax K100D series camera, the AF540FGZ auto flash provides a variety of advanced flash applications, including P-TTL auto flash, high-speed synchronization, and wireless P-TTL auto flash.

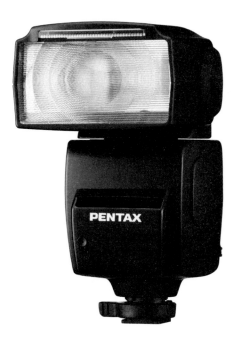

match the lens' focal length. The power-zoom flash head covers angles-of-view for 24 to 85mm lenses. A built-in wide-angle panel slides out to cover a 20mm angle of view.

Using the AF540FGZ with K100D series cameras offers some interesting photographic options for using flash.

Off-Camera Flash

Putting a flash on a dedicated flash cord (Off-camera Shoe Adapter F) allows you to move the flash away from the camera and still have it work automatically. Using the LCD monitor, you can see exactly what the effects are so you can move the flash up or down, left or right, for the best light and shadows on your subject.

Colored Light

Many flashes look better with a slight warming filter on them, but this is not what we're after here. With multiple light sources, you can attach colored filters (sometimes called gels) to the various flashes to achieve different colors of light in various parts of the photo. One of my favorite outdoor fashion techniques is to set the camera's white balance to Tungsten and tape an 85 Gel filter on the flash. This makes the subject properly color balanced but makes the background bluish! Since the illustrations in the book are monochrome I can't show you this trick, but try it, I think you'll like it!

Wireless Flash

The Off-camera Shoe Clip CL-10 is an attachment for using the Pentax AF540FGZ or AF360FGZ as a wireless slave flash. By using two shoe-mount flashes (AF540FGZ or AF360FGZ), you can fire the flash without connecting the second flash to the camera with a cord.

Step 1: Place the external flash at the desired location.

Step 2: Set the power switch on that unit to WIRELESS.

Step 3: Set its wireless mode to [S] Slave.

Step 4: Turn on the camera and set the mode dial to P, Tv, Av, or M.

Step 5: Set the power switch on the flash mounted on the K100D's hot shoe to WIRELESS.

Step 6: Set the mounted flash's wireless mode to [M] Master. Be sure both flashes are set to the same channel.

Note: Wireless flash is not available with the K100D's built-in flash.

Bounce Flash

The AF540FGZ's bounce flash function has adjustable angles of -10° to 90° vertically and up to 180° horizontally. Direct flash can often be harsh and unflattering, causing heavy shadows behind the subject or underneath features such as eyebrows and hair. Bouncing the flash off the wall or ceiling softens the light and creates a more natural-looking light effect.

When making portraits, I typically shoot in Program mode and almost always—indoors and out—attach a Sto-Fen Omni-Bounce diffuser on the flash to soften the direction and intensity of the light (www.stofen.com). The flash head itself is often tilted in some oddball direction to avoid that dreaded, flat "flash-on-camera look." As I write this, Sto-Fen does not make an Omni-Bounce specifically for the AF540FGZ, but offers one for the AF360FGZ and five other Pentax flash units. Sto-fen tells me that the Omni Bounce designed for the Olympus OM-MZ40 flash is a "very good fit."

Note: I made the shots in this chapter with the AF540FGZ and an Omni Bounce designed for a Canon flash. Not a perfect fit, but it worked.

Close-Up Flash

Close-up flash photography used to be a real problem for anyone except for those willing to spend some time experimenting. Now you can see exactly what the flash does to the subject with any number of test shots. This works well with off-camera flash, as you can "feather" the light (aim it so it doesn't hit the subject directly or use a diffuser) to gain control over its strength and how it lights the area around the subject.

Balancing Light to Interiors

Architectural and corporate photographers have always used added light to fill in dark areas of a scene so the scene looks softer. Instead of using expensive Polaroid test prints, double-check the light balance on your subject using the LCD monitor. You can even be sure the added light is the right color by attaching filters to the flash to mimic or match lights (such as a green filter to match the color of fluorescent lights). You can also use a green Sto-Fen Omni-Bounce (easier to use than duct taping a filter). When pointed straight up, this combination provides the same kind of effect used in shadowless bare tube-style studio lighting.

I made this photo with the AF540FGZ external flash attached to the K100D and bounced the flash. To provide some direct light to the model's face, I attached a Sto-Fen Omni Bounce diffuser to the flash. I increased the exposure compensation plus one stops to accent the high-key look.

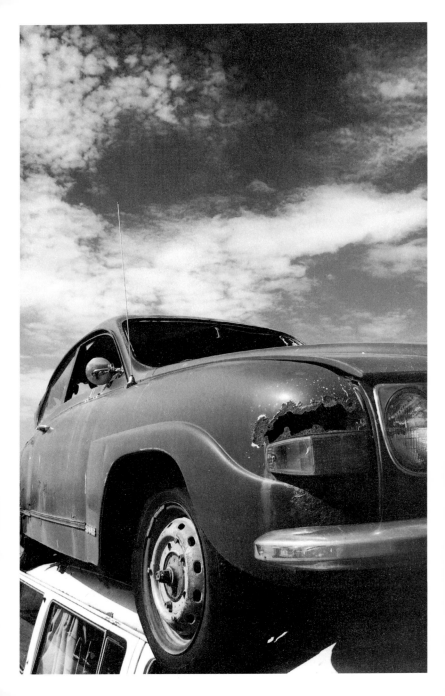

Working with Your Computer

Several years ago, I sold all of my traditional darkroom equipment. After sitting untouched in the basement of my new home far too long, I decided it had to go. I loaded the enlarger, lenses, carriers, and trays into my car, and took them to a local photo show and sold them to practitioners of silver halide reproduction for below bargain prices. Why? I had long since made the transition to the digital darkroom. Now that those boxes upon boxes of traditional darkroom gear are gone, I haven't looked back.

From the K100D to Your Computer

The times they are a changing. You don't need a computer for digital imaging anymore. Digital mini labs make creating inexpensive prints from your memory cards or digital files easy. However, just as the person who wants to create expressive images with film needs a darkroom, the digital photographer who wants more control over the look of his or her images needs a digital darkroom.

Much as the center of the traditional darkroom is the enlarger, the heart of that digital darkroom is the computer. There are two main ways of getting digital files off of the SD card and into the computer. One way is to connect your K100D series camera to the computer with the cable Pentax provides. This is fine if it's all you've got, but buying a card reader that stays plugged into your computer so you don't have to fiddle with cords or drain the camera battery to download is a much better way to go. Purchase a multiple format card reader that reads all kinds of media, not just SD or MMC cards. Even if your current camera only uses one media type, you never know what your next camera will

⟵ *I took this photo at Blake's Small Car Salvage yard in Erie, Colorado with a K100D and the 12-24mm smc Pentax lens.*

With slots dedicated to eight types of media, Belkin's Hi-Speed USB 2.0 8-in-1 Media Reader has the ability to read and/or write CompactFlash I or II, Smart-Media, IBM Microdrive, Secure Digital, Multimedia Card, Memory Stick, and Sony's Mem-oryGate Memory Stick.

use. Some multiple format card readers even allow you to drag and drop images files from one memory card to another! There are lots of card readers to choose from.

Comparing Interfaces

Performance may be one of the most important aspects in selecting which kind of computer connection you want to make with your card reader. This chart compares various types of peripheral connections along with their data transfer rates in megabytes per second (MB/s) or megabits per second (Mb/s).

USB	1.5 to 12 Mb/s
USB 2.0	480 Mb/s
FireWire	12.5 to 50 Mb/s

Why Use a Card Reader?

While there are those, especially in the camera industry, who think photographers will connect their camera directly to the computers using the cords they thoughtfully provide, the reality is that the memory card and the camera are often in different places. The advantage to downloading directly from the camera is that you don't need to buy a card reader.

SanDisk's ImageMate 12-in-1 is a multi-card USB 2.0 reader that is also compatible with the slower USB 1.1 ports. It has the ability to write data to and read data from CompactFlash Type I/II, SD, min-iSD, MMC, RS-MMC, Memory Stick (including PRO, Duo and PRO Duo), along with SmartMedia and xD cards.

However, there are some distinct disadvantages, including the fact that the camera has to be unplugged after each use (the card reader can be left attached to the computer).

Transferring images from your camera via a card reader can be slow unless you're using a USB 2.0 or FireWire reader. USB 2.0 readers are inexpensive and fast. Make sure your computer has USB 2.0 connection, not just a "USB-compatible" one. What that means is that the port is really USB 1.1, which is ten times slower than USB 2.0. It is easy and inexpensive to add USB ports to your computer, so just do it! You've got better things to do that wait for files to be moved.

Workflow

Let's face it; most of us had this whole film thing figured out. We shot pictures of everything that caught our fancy, made 4 x 6-inch prints (approximately size C6) at a one-hour lab, and occasionally ordered one of those big 8 x 10 –inch enlargements (approximately size A4). Then, we mail some photos to friends and family, stick the leftovers in a shoebox, then a bigger shoebox, then several shoeboxes stacked somewhere in a corner of the attic, basement, or garage.

With digital photography, it's a bit different. You see, all those shoe boxes were more or less free, but hard disk space costs money, though it's getting less expensive every day. In any case, there's more to this process than just accumulating more hard drive space, so unless you've got an unlimited budget, you're going to need a digital workflow solution.

Here's a step-by-step run through of what I do with digital images after they are captured. This may not a perfect solution for everyone, especially if you don't take the same number and kinds of photographs that I do, but it should give you an idea of where to start as you create your own digital workflow.

Step 1: Get rid of the "throw-away" shots in-camera. During a break in shooting, take the time to scroll through the images on your camera's LCD monitor and erase the ones that clearly don't make the grade. Don't be too hard on yourself (unless you don't have a lot of memory card space left) and save any marginal shots for a more critical evaluation later.

When you come back from a trip, what do you do with the digital images you captured? This chapter offers a few suggestions.
© Hisashi Tatamiya

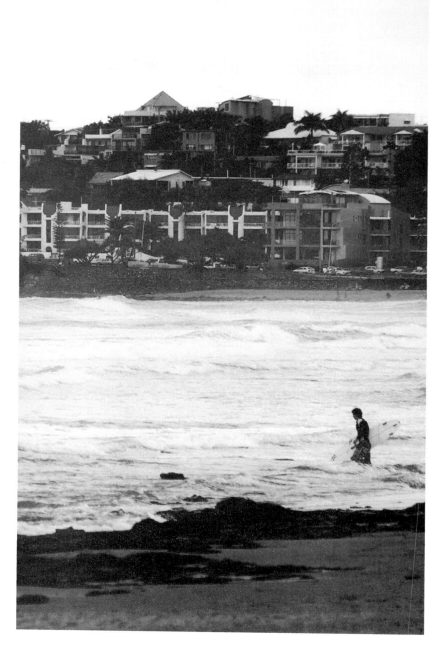

Step 2: The next thing to do is to download the images from your memory card to your computer using either the cord the came with the camera or a card reader. To sift through and organize your images, you're going to need an image management program (sometimes called browser software). Pentax provides a program called Photo Browser with the K100D series cameras. It's a good place to get started, and you don't have to expend any additional cost to try it out. If you later decide you would prefer more sophisticated software, there are plenty of options out there for you to choose from. (See page 187 for more about image management programs.)

Step 3: After I have downloaded and reviewed my images, I then create folders on the computer's hard drive, label them with names that are indicative of the image contents I will place there, and drag and drop my images into the appropriate places. For example, one weekend I shot more than 1,500 images, so I started by creating a folder with the name of the event and where it took place. Then I created additional folders inside that one with names reflecting various subject matter from that weekend.

Step 4: Next, I make a CD or DVD that holds all of the images I just downloaded, organized, and labeled. The disc serves as a backup to the images stored on your hard drive. Be sure to label the disc so that, when you pick it up some day in the future, you'll know what's on it! You can then take your CD or DVD to your neighborhood digital printing kiosk to make prints, or print at home if you have the equipment for it.

This photograph is a "keeper," but we all take a bad photograph now and again. Delete sub-par shots in-camera so that later when you download the image files, only the good ones are transferred.

185

The Photo Browser program that comes with the K100D has the capability to show both the next and previous images in the main image window during image review. This is the Windows version, but a Mac OS version is also included in the software package you received.

Step 5: The image files on your hard drive should be considered temporary. Once you have backed up your images to CD, thereby saving the originals, go back and select which images you'd like to crop, color correct, or manipulate to create a better-looking file. These image files can be kept in the same folders as the originals; I usually name them something different so that the original file is untouched (i.e., the edited Thomas.jpg image might be saved as Thomas_2.jpg). When my hard drive starts to get crowded, I look at the oldest folders and, before erasing them from the drive, copy all of the information—both originals and edited files—onto a CD or DVD. Then, I replace the older backup disc I made of those files with my new one.

Image Management Programs

While the newest version of Adobe Photoshop has an improved browser called Bridge that can help organize photos, some people feel that it still doesn't do as well as software specifically made for this purpose. (I think it does just fine.) Many image management programs include database functions (such as keyword searches) and are available for Mac OS and/or Windows. These programs allow you to quickly look at photos on your computer, rename them one at a time or all at once, read all major files (including RAW) formats, move images files from folder to folder, resize photos for emailing, create simple slideshows, and more.

An important function of some image management programs is the ability to print customized index prints. You can title each index print according to the picture set it represents, and can often also list additional information, such as the photographer's name and address or image file locations. The index print serves as a reference that can be used for visual searches. You might even want to include an index print with every CD or DVD you make so you can quickly reference what is on the disc and find the file you need. A combination of labeled folders on your hard drive, a good image management program, and index prints to go with your backup discs will help you to maintain a fast and easy way to find and sort images.

Pentax Photo Browser

Pentax Photo Browser, for both Mac OS and Windows XP, is an excellent introductory image management software and comes bundled with your K100D series camera. It is designed for viewing, printing, and managing the images stored on your computer. This software supports BMP, JPEG, PEF (Pentax's proprietary RAW file), PICT, PNG, and TIFF image file formats. When you select a folder containing image files, they automatically appear on the screen as thumbnails (small pictures), and you can select a thumbnail to view as a larger image.

Each panel in the main Pentax Photo Browser window can be resized from side-to-side and up and down to fit your work style. This shot of the Mac OS version was captured on a wide-screen monitor.

The toolbar contains a number of useful image processing tools to improve your images. First, use the Zoom tool to look at your photos up close; any that don't look all that great can be deleted using the Delete button with the trash can icon. (The original should be safe and sound on the backup CD or DVD you burned immediately after copying the files to your hard drive.) Then, you can tweak some of the less-than perfect files using the Auto Image Fix that automatically adjusts brightness, contrast, and color tone.

Pentax Photo Laboratory

This software is on the same disc as the Pentax Photo Browser software; both programs come with your K100D series camera. Pentax Photo Library gives you access to PEF files (Pentax's proprietary RAW files) and can be run from within Pentax Photo Browser or as a standalone application.

Pentax Photo Laboratory is a gateway to RAW image processing and lets you open, enhance, and save in five different JPEG or TIFF file formats.

Pentax Photo Laboratory lets you open, enhance, and save JPEG file types at five different compression ratios, or you can elect to save in an 8- or 16-bit TIFF file format. It offers full automatic processing, or you can custom process each image using the White Balance, Tone, and Other settings panels. While not as advanced or comprehensive as Adobe Camera RAW, Pentax Photo Laboratory provides an excellent introduction to the world of RAW image file processing.

After you install Pentax Photo Browser and Pentax Photo Laboratory on your Mac OS or Windows XP computer, the next thing to do is go to the Pentax Imaging website (www.pentaximaging.com) and go to the Customer Care & Support section, then click on Self Support. Here is where you can find software updates. It's always a good idea to use the very latest software so you can extract the best possible image quality from your camera's image files, and software updates will often add features and increase performance.

Image Processing

Photographs are not always completely finished at that decisive moment when they're captured. Many of us can't resist the urge to improve that original image to reflect what we saw in our mind's eye. The legendary photographer Ansel Adams called this process "previsualization," and the tool he used for producing a finished image is called the Zone System. What's that got to do with image processing software, you might ask? In the introduction of the second edition of "The Negative" (1981) Adams says, "I eagerly await new concepts and processes. I believe that the electronic image will be the next major advance. Such systems will have their own inherent and inescapable structural characteristics, and the artist and functional practitioner will again strive to comprehend and control them."

Buying the right digital imaging software can be confusing. There are many different image enhancement products, from low-priced entry-level image processing programs to professional level packages. Sorting out which one is right for you should starts with an assessment of your needs. Start by asking yourself the following questions:

What kind of computer do you use? Some programs are available for both Mac and PC computers, but others are specifically designed for one or the other.

How are you going to use the software? When it comes to choosing an image-processing program, my advice is to focus on your short-term imaging goals. By the time you've had enough experience with a program to use most of all its features comfortably, it's likely that newer generations of your software or even new superior products will have been introduced.

Is your main objective to create images for use on the Internet? If all you want to do is post or email photographs, these low-resolution images require much less image-processing horsepower and a less expensive, less complicated program may work just fine for you.

Is your main objective to print fine art images to sell at art shows and galleries? In this case, you will want a highly capable software that will meet all your image processing needs. Remember, you don't have to know how to use every feature available in a particular program just so long as it does everything you need it to do.

Storing Your Images

Even though your images are stored as digital files, they can still be lost or destroyed without proper care. Some photographers use two hard drives, either adding a second one to the inside of the computer or using an external USB or FireWire drive. This allows you to immediately and easily back up photos on the second drive. It is rare for two hard drives to fail at once, though it is still recommended that you burn your images to CD. Me? I store my images on a 1 TB storage device (one terabyte—equal to 1,024 gigabytes) called the Yellow Machine (www.yellowmahcine.com).

When I write an image file or folder to one drive in the Yellow Machine, it automatically writes a duplicate file to another drive. Even so, I still save copies of that folder on a DVD or CD and store it in my archives.

Hard drives are magnetic media; they do a great job at recording image files for processing and transmitting, but they may not be the best choice for long-term storage. Any number of malicious computer viruses can wipe out files

from a hard drive, and even the best drives can crash, rendering them unusable. Plus, we are all capable of accidentally erasing or saving over an important photo.

A CD or DVD writer (also called a CD or DVD burner) is a necessity for the digital photographer. Writeable DVDs aren't as cheap as a writeable CDs, but the discs themselves can handle about eight times more data. Either option allows you to back up photo files and store images safely.

There are two types of disc media that can be used for recording data: R designated media (i.e., CD-R or DVD-R) means that the disc is recordable; RW designated media (i.e., CD-RW or DVD-RW) means that the disc is rewriteable. R CDs or DVDs can only be recorded on once. They cannot be erased and no new images can be added to them. RWs, on the other hand, can be recorded on and then erased and reused, and you can add more data to them, as well, up to the point that the disc space allows. RW discs don't actually erase the media the way a Zip disk or hard drive does. Instead it just writes the latest version of the file and ignores the old one. All the original data is still on the disc.

You should always purchase quality media from well-known companies. Inexpensive discs may not preserve your image files as long as you would like them to. Read the box. Look for information about the life of the disc. Most long-lived discs are labeled as such and cost a little more.

This DVD-R uses a high quality organic dye that ensures reliable recording and playback, and it's certified for up to 16X DVD recording speeds. Storage acceleration tests guarantee safe storage for more than 30 years.

Direct **Printing**

The K100D series cameras let you print images directly from camera to printer using PictBridge technology and the USB cable that Pentax packages with the camera. Start by setting the camera's [Transfer Mode] feature (see pages 95-96), then turn off the camera; the printer must be turned on first for direct printing. Keep in mind that PictBridge only works with JPEG files. Any images captured in the PEF format cannot be printed directly from the camera. After the printer has started up, turn on the camera. When you do, the [PictBridge] menu appears giving you three choices:

* [Print One]
* [Print All]
* [DPOF AUTOPRINT] (see page 194)

To print a single image, choose [Print One], then use the four-way controller to choose an image to print and how many copies (up to 99). Press the **Fn** button if you want to insert the date. Pressing the **OK** button brings up the confirmation screen. To make changes in paper size, type, quality, or picture borders, press the **Fn** button then use the four-way controller to make changes. When you're finished, press the **OK** button twice to make the prints.

Printing all the images is also a piece of cake. Just select [Print All] from the [PictBridge] menu, then follow the exact same steps outlined above, except that you're applying your choices to all the photos, not just one. You can press the MENU button at any time to cancel printing.

Hint: Use the AC adapter when printing to save battery life, and be sure not to disconnect the USB cable during transfer.

PictBridge

The Camera & Imaging Products Association (www.cipa.jp), more commonly known as PictBridge, provides a direct connect solution for image input and output devices by standardizing services for them. The current and most common release from PictBridge focuses on direct print services between a digital still cameras and printers.

Digital Print Order Format (DPOF)

Digital Print Order Format is a feature that's found in the K100D series cameras, as well as in most digital cameras these days, that enables the camera to supply data about the printing of image files and the supplementary information contained within them. DPOF consists of a set of text files stored in a special directory on the memory card. For the system to operate, the printer must be DPOF compatible, and DPOF cannot be applied to PEF/RAW files.

This option can be accessed through the K100D's DPOF mode. With the camera in Playback mode, use the buttons in the four-way controller to select the photo you want to print, then press the (icon 6) button and you will see DPOF. Press the UP arrow and you're in DPOF mode. Now you can choose how many copies you want (up to 99) and whether or not you want the date printed. When you press the (icon 5) button, those settings are stored with the image file and the camera is returned to Playback mode.

To apply the same settings to all the image files, get to the DPOF menu as before, then press the (icon 6) button. This will give you a screen that lets you choose the number of copies and if the date is to be printed, but it applies to all of the files on the SD card. Press the (icon 5) button and you're ready to take the memory card to a photo kiosk or use it with a DPOF compatible desktop printer at home.

This photograph of Bryce Canyon was made with a Pentax K100D ⇨
and an smc P-DA 50-200mm zoom lens.

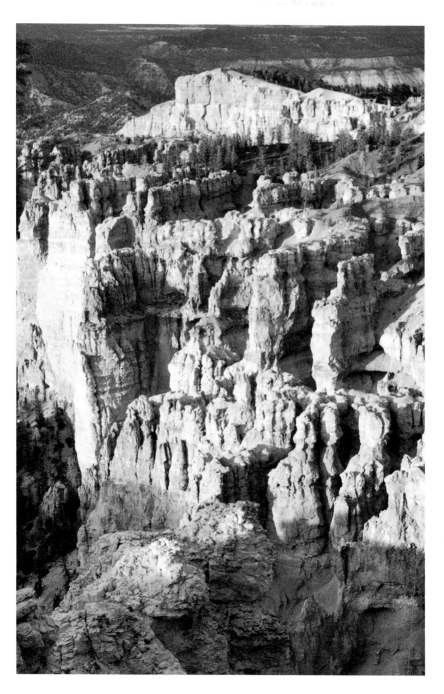

Glossary

aberration
An optical flaw in a lens that causes the image to be distorted or unclear.

Adobe Photoshop
Professional-level image-processing software with extremely powerful filter and color-correction tools. It offers features for photography, graphic design, web design, and video.

Adobe Photoshop Elements
A limited version of the Photoshop program, designed for the avid photographer. The Elements program lacks some of the more sophisticated controls available in Photoshop, but it does have a comprehensive range of image-manipulation options, such as cropping, exposure and contrast controls, color correction, layers, adjustment layers, panoramic stitching, and more.

AE
See automatic exposure.

AF
See automatic focus.

ambient light
See available light.

angle of view
The area seen by a lens, usually measured in degrees across the diagonal of the film frame.

anti-aliasing
A technique that reduces or eliminates the jagged appearance of lines or edges in an image.

aperture
The opening in the lens that allows light to enter the camera. Aperture is usually described as an f/number. The higher the f/number, the smaller the aperture; and the lower the f/number, the larger the aperture.

Aperture-Priority mode (Av)
A type of automatic exposure in which you manually select the aperture and the camera automatically selects the shutter speed.

artifact
Information that is not part of the scene but appears in the image due to technology. Artifacts can occur in film or digital images and include increased grain, flare, static marks, color flaws, noise, etc.

artificial light
Usually refers to any light source that doesn't exist in nature, such as incandescent, fluorescent, and other manufactured lighting.

astigmatism
An optical defect that occurs when an off-axis point is brought to focus as sagittal and tangential lines rather than a point.

automatic exposure
When the camera measures light and makes the adjustments necessary to create proper image density on sensitized media.

automatic flash
An electronic flash unit that reads light reflected off a subject (from either a preflash or the actual flash exposure), then shuts itself off as soon as ample light has reached the sensitized medium.

automatic focus
When the camera automatically adjusts the lens elements to sharply render the subject.

Av
Aperture Value. See Aperture-Priority mode.

available light
The amount of illumination at a given location that applies to natural and artificial light sources but not those supplied specifically for photography. It is also called existing light or ambient light.

backlight
Light that projects toward the camera from behind the subject.

backup
A copy of a file or program made to ensure that, if the original is lost or damaged, the necessary information is still intact.

barrel distortion
A defect in the lens that makes straight lines curve outward away from the middle of the image.

bit
Binary digit. This is the basic unit of binary computation. See also, byte.

bit depth
The number of bits per pixel that determines the number of colors the image can display. Eight bits per pixel is the minimum requirement for a photo-quality color image.

bounce light
Light that reflects off of another surface before illuminating the subject.

bracketing
A sequence of pictures taken of the same subject but varying one or more exposure settings, manually or automatically, between each exposure.

brightness
A subjective measure of illumination. See also, luminance.

buffer
Temporarily stores data so that other programs, on the camera or the computer, can continue to run while data is in transition.

built-in flash
A flash that is permanently attached to the camera body. The built-in flash will pop up and fire in low-light situations when using the camera's automated exposure settings.

built-in meter
A light-measuring device that is incorporated into the camera body.

Bulb (B)
A camera setting that allows the shutter to stay open as long as the shutter release is depressed.

byte
A single group of eight bits that is processed as one unit. See also, bit.

card reader
Device that connects to your computer and enables quick and easy download of images from memory card to computer.

chromatic aberration
Occurs when light rays of different colors are focused on different planes, causing colored halos around objects in the image.

chrominance
Hue and saturation information.

chrominance noise
A form of artifact that appears as a random scattering of densely packed colored "grain." See also, luminance and noise.

close-up
A general term used to describe an image created by closely focusing on a subject. Often involves the use of special lenses or extension tubes. Also, an automated exposure setting that automatically selects a large aperture (not available with all cameras).

CMYK mode
Cyan, magenta, yellow, and black. This mode is typically used in image-editing applications when preparing an image for printing.

color balance
The average overall color in a reproduced image. How a digital camera interprets the color of light in a scene so that white or neutral gray appear neutral.

color cast
A colored hue over the image often caused by improper lighting or incorrect white balance settings. Can be produced intentionally for creative effect.

color space
A mapped relationship between colors and computer data about the colors.

CompactFlash (CF) card
One of the most widely used removable memory cards.

complementary colors
In theory: any two colors of light that, when combined, emit all known light wavelengths, resulting in white light. Also, it can be any pair of dye colors that absorb all known light wavelengths, resulting in black.

compression
Method of reducing file size through removal of redundant data, as with the JPEG file format.

contrast
The difference between two or more tones in terms of luminance, density, or darkness.

contrast filter
A colored filter that lightens or darkens the monotone representation of a colored area or object in a black-and-white photograph.

CPU
Central Processing Unit. This is the "brains" of a computer or a lens that perform principle computational functions.

critical focus
The most sharply focused plane within an image.

cropping
The process of extracting a portion of the image area. If this portion of the image is enlarged, resolution is subsequently lowered.

dedicated flash
An electronic flash unit that talks with the camera, communicating things such as flash illumination, lens focal length, subject distance, and sometimes flash status.

default
Refers to various factory-set attributes or features, in this case of a camera, that can be changed by the user but can, as desired, be reset to the original factory settings.

depth of field
The image space in front of and behind the plane of focus that appears acceptably sharp in the photograph.

diaphragm
A mechanism that determines the size of the lens opening that allows light to pass into the camera when taking a photo.

digital zoom
The cropping of the image at the sensor to create the effect of a telephoto zoom lens. The camera interpolates the image to the original resolution. However, the result is not as sharp as an image created with an optical zoom lens because the cropping of the image reduced the available sensor resolution.

diopter
A measurement of the refractive power of a lens. Also, it may be a supplementary lens that is defined by its focal length and power of magnification.

download
The transfer of data from one device to another, such as from camera to computer or computer to printer.

dpi
Dots per inch. Used to define the resolution of a printer, this term refers to the number of dots of ink that a printer can lay down in an inch.

D-SLR
A digital single-lens reflex camera. See also, SLR.

dye sublimation printer
Creates color on the printed page by vaporizing inks that then solidify on the page.

electronic flash
A device with a glass or plastic tube filled with gas that, when electrified, creates an intense flash of light. Also called a strobe. Unlike a flash bulb, it is reusable.

electronic rangefinder
A system that utilizes the AF technology built into a camera to provide a visual confirmation that focus has been achieved. It can operate in either manual or AF focus modes.

EV
Exposure value. A number that quantifies the amount of light within an scene, allowing you to determine the relative combinations of aperture and shutter speed to accurately reproduce the light levels of that exposure.

EXIF
Exchangeable Image File Format. This format is used for storing an image file's interchange information.

exposure
When light enters the camera and reacts with the sensitized medium. The term can also refer to the amount of light that strikes the light sensitive medium.

exposure meter
See light meter.

extension tube
A hollow metal ring that can be fitted between the camera and lens. It increases the distance between the optical center of the lens and the sensor and decreases the minimum focus distance of the lens.

f/
See f/stop

FAT
File Allocation Table. This is a method used by computer operating systems to keep track of files stored on the hard drive.

file format
The form in which digital images are stored and recorded, e.g., JPEG, RAW, TIFF, etc.

filter
Usually a piece of plastic or glass used to control how certain wavelengths of light are recorded. A filter absorbs selected wavelengths, preventing them from reaching the light sensitive medium. Also, software available in image-processing computer programs can produce special filter effects.

FireWire
A high speed data transfer standard that allows outlying accessories to be plugged and unplugged

from the computer while it is turned on. Some digital cameras and card readers use FireWire to connect to the computer. FireWire transfers data faster than USB. See also, Mbps.

firmware
Software that is permanently incorporated into a hardware chip. All computer-based equipment, including digital cameras, use firmware of some kind.

flare
Unwanted light streaks or rings that appear in the viewfinder, on the recorded image, or both. It is caused by extraneous light entering the camera during shooting. Diffuse flare is uniformly reflected light that can lower the contrast of the image. Zoom lenses are susceptible to flare because they are comprised of many elements. Filters can also increase flare. Use of a lens hood can often reduce this undesirable effect.

f/number
See f/stop.

focal length
When the lens is focused on infinity, it is the distance from the optical center of the lens to the focal plane.

focal plane
The plane on which a lens forms a sharp image. Also, it may be the film plane or sensor plane.

focus
An optimum sharpness or image clarity that occurs when a lens creates a sharp image by converging light rays to specific points at the focal plane. The word also refers to the act of adjusting the lens to achieve optimal image sharpness.

f/stop
The size of the aperture or diaphragm opening of a lens, also referred to as f/number or stop. The term stands for the ratio of the focal length (f) of the lens to the width of its aperture opening. (f/1.4 = wide opening and f/22 = narrow opening.) Each stop up (lower f/number) doubles the amount of light reaching the sensitized medium. Each stop down (higher f/number) halves the amount of light reaching the sensitized medium.

full-frame
The maximum area covered by the sensitized medium.

full-sized sensor
A sensor in a digital camera that has the same dimensions as a 35mm film frame (24 x 36 mm).

GB
See gigabyte.

gigabyte
Just over one billion bytes.

GN
See guide number.

gray card
A card used to take accurate exposure readings. It typically has a white side that reflects 90% of the light and a gray side that reflects 18%.

gray scale
A successive series of tones ranging between black and white, which have no color.

guide number
A number used to quantify the output of a flash unit. It is derived by using this formula: GN = aperture x distance. Guide numbers are expressed for a given ISO film speed in either feet or meters.

hard drive
A contained storage unit made up of magnetically sensitive disks.

histogram
A graphic representation of image tones.

hot shoe
An electronically connected flash mount on the camera body. It enables direct connection between the camera and an external flash, and synchronizes the shutter release with the firing of the flash.

icon
A symbol used to represent a file, function, or program.

image-editing program
See image-processing program.

image-processing program
Software that allows for image alteration and enhancement.

infinity
In photographic terms, the theoretical most distant point of focus.

interpolation
Process used to increase image resolution by creating new pixels based on existing pixels. The software intelligently looks at existing pixels and creates new pixels to fill the gaps and achieve a higher resolution.

IS
Image Stabilization. This is a technology that reduces camera shake and vibration. It is used in lenses, binoculars, camcorders, etc.

ISO
From ISOS (Greek for equal), a term for industry standards from the International Organization for Standardization. When an ISO number is applied to film, it indicates the relative light sensitivity of the recording medium. Digital sensors use film ISO equivalents, which are based on enhancing the data stream or boosting the signal.

JFET
Junction Field Effect Transistor, which are used in digital cameras to reduce the total number of transistors and minimize noise.

JPEG
Joint Photographic Experts Group. This is a lossy compression file format that works with any computer and photo software. JPEG examines an image for redundant information and then removes it. It is a variable compression format because the amount of leftover data depends on the detail in the photo and the amount of compression. At low compression/high quality, the loss of data has a negligible effect on the photo. However, JPEG should not be used as a working format—the file should be reopened and saved in a format such as TIFF, which does not compress the image.

KB
See kilobyte.

kilobyte
Just over one thousand bytes.

latitude
The acceptable range of exposure (from under to over) determined by observed loss of image quality.

LCD
Liquid Crystal Display, which is a flat screen with two clear polarizing sheets on either side of a liquid crystal solution. When activated by an electric current, the LCD causes the crystals to either pass through or block light in order to create a colored image display.

LED
Light Emitting Diode. It is a signal often employed as an indicator on cameras as well as on other electronic equipment.

lens
A piece of optical glass on the front of a camera that has been precisely calibrated to allow focus.

lens hood
Also called a lens shade. This is a short tube that can be attached to the front of a lens to reduce flare. It keeps undesirable light from reaching the front of the lens and also protects the front of the lens.

lens shade
See lens hood.

light meter
Also called an exposure meter, it is a device that measures light levels and calculates the correct aperture and shutter speed.

lithium-ion
A popular battery technology (sometimes abbreviated to Li-ion) that is not prone to the charge memory effects of nickel-cadmium (Ni-Cd) batteries, or the low temperature performance problems of alkaline batteries.

long lens
See telephoto lens.

lossless
Image compression in which no data is lost.

lossy
Image compression in which data is lost and, thereby, image quality is lessened. This means that the greater the compression, the lesser the image quality.

low-pass filter
A filter designed to remove elements of an image that correspond to high-frequency data, such as sharp edges and fine detail, to reduce the effect of moiré. See also, moiré.

luminance
A term used to describe directional brightness. It can also be used as luminance noise, which is a form of noise that appears as a sprinkling of black "grain." See also, brightness, chrominance, and noise.

Mac
Macintosh. This is the brand name for computers produced by Apple Computer, Inc.

macro lens
A lens designed to be at top sharpness over a flat field when focused at close distances and reproduction ratios up to 1:1.

main light
The primary or dominant light source. It influences texture, volume, and shadows.

Manual exposure mode (M)
A camera operating mode that requires the user to determine and set both the aperture and shutter speed. This is the opposite of automatic exposure.

MB
See megabyte.

Mbps
Megabits per second. This unit is used to describe the rate of data transfer. See also, megabit.

megabit
One million bits of data. See also, bit.

megabyte
Just over one million bytes.

megapixel
A million pixels.

memory
The storage capacity of a hard drive or other recording media.

memory card
A solid state removable storage medium used in digital devices. They can store still images, moving images, or sound, as well as related file data. There are several different types, including CompactFlash, SmartMedia, and xD, or Sony's proprietary Memory Stick, to name a few. Individual card capacity is limited by available storage as well as by the size of the recorded data (determined by factors such as image resolution and file format). See also, CompactFlash (CF) card, file format.

menu
A listing of features, functions, or options displayed on a screen that can be selected and activated by the user.

microdrive
A removable storage medium with moving parts. They are miniature hard drives based on the dimensions of a Compact-Flash Type II card. Microdrives are more susceptible to the effects of impact, high altitude, and low temperature than solid-state cards are. See also, memory card.

middle gray
Halfway between black and white, it is an average gray tone with 18% reflectance. See also, gray card.

midtone
The tone that appears as medium brightness, or medium gray tone, in a photographic print.

mode
Specified operating conditions of the camera or software program.

moiré
Occurs when the subject has more detail than the resolution of the digital camera can capture. Moiré appears as a wavy pattern over the image.

noise
The digital equivalent of grain. It is often caused by a number of different factors, such as a high ISO setting, heat, sensor design, etc. Though usually undesirable, it may be added for creative effect using an image-processing program. See also, chrominance noise and luminance.

normal lens
See standard lens.

operating system (OS)
The system software that provides the environment within which all other software operates.

overexposed
When too much light is recorded with the image, causing the photo to be too light in tone.

pan
Moving the camera to follow a moving subject. When a slow shutter speed is used, this creates an image in which the subject appears sharp and the background is blurred.

PC
Personal Computer. Strictly speaking, a computer made by IBM Corporation. However, the term is commonly used to refer to any IBM compatible computer.

perspective
The effect of the distance between the camera and image elements upon the perceived size of objects in an image. It is also an expression of this three-dimensional relationship in two dimensions.

pincushion distortion
A flaw in a lens that causes straight lines to bend inward toward the middle of an image.

pixel
Derived from picture element. A pixel is the base component of a digital image. Every individual pixel can have a distinct color and tone.

plug-in
Third-party software created to augment an existing software program.

polarization
An effect achieved by using a polarizing filter. It minimizes reflections from non-metallic surfaces like water and glass and saturates colors by removing glare. Polarization often makes skies appear bluer at 90 degrees to the sun. The term also applies to the above effects simulated by a polarizing software filter.

pre-flashes
A series of short duration, low intensity flash pulses emitted by a flash unit immediately prior to the shutter opening. These flashes help the TTL light meter assess the reflectivity of the subject. See also, TTL.

Program mode (P)
In Program exposure mode, the camera selects a combination of shutter speed and aperture automatically.

RAM
Stands for Random Access Memory, which is a computer's memory capacity, directly accessible from the central processing unit.

RAW
An image file format that has little or no internal processing applied by the camera. It contains 12-bit

color information, a wider range of data than 8-bit formats such as JPEG.

RAW+JPEG
An image file format that records two files per capture; one RAW file and one JPEG file.

rear curtain sync
A feature that causes the flash unit to fire just prior to the shutter closing. It is used for creative effect when mixing flash and ambient light.

red-eye reduction
A feature that causes the flash to emit a brief pulse of light just before the main flash fires. This helps to reduce the effect of retinal reflection.

resolution
The amount of data available for an image as applied to image size. It is expressed in pixels or megapixels, or sometimes as lines per inch on a monitor or dots per inch on a printed image.

RGB mode
Red, Green, and Blue. This is the color model most commonly used to display color images on video systems, film recorders, and computer monitors. It displays all visible colors as combinations of red, green, and blue. RGB mode is the most common color mode for viewing and working with digital files onscreen.

saturation
The intensity or richness of a hue or color.

sharp
A term used to describe the quality of an image as clear, crisp, and perfectly focused, as opposed to fuzzy, obscure, or unfocused.

short lens
A lens with a short focal length—a wide-angle lens. It produces a greater angle of view than you would see with your eyes.

shutter
The apparatus that controls the amount of time during which light is allowed to reach the sensitized medium.

Shutter-Priority mode (Tv)
An automatic exposure mode in which you manually select the shutter speed and the camera automatically selects the aperture.

slow sync
A flash mode in which a slow shutter speed is used with the flash in order to allow low-level ambient light to be recorded by the sensitized medium.

SLR
Single-lens reflex. A camera with a mirror that reflects the image entering the lens through a pentaprism or pentamirror onto the viewfinder screen. When you take the

picture, the mirror reflexes out of the way, the focal plane shutter opens, and the image is recorded.

small-format sensor
In a digital camera, this sensor is physically smaller than a 35mm frame of film. The result is that standard 35mm focal lengths act like longer lenses because the sensor sees an angle of view smaller than that of the lens.

standard lens
Also known as a normal lens, this is a fixed-focal-length lens usually in the range of 45 to 55mm for 35mm format (or the equivalent range for small-format sensors). In contrast to wide-angle or telephoto lenses, a standard lens views a realistically proportionate perspective of a scene.

stop
See f/stop.

stop down
To reduce the size of the diaphragm opening by using a higher f/number.

stop up
To increase the size of the diaphragm opening by using a lower f/number.

strobe
Abbreviation for strobo-scopic. An electronic light source that produces a series of evenly spaced bursts of light.

synchronize
Causing a flash unit to fire simultaneously with the complete opening of the camera's shutter.

telephoto effect
When objects in an image appear closer than they really are through the use of a telephoto lens.

telephoto lens
A lens with a long focal length that enlarges the subject and produces a narrower angle of view than you would see with your eyes.

thumbnail
A miniaturized representation of an image file.

TIFF
Tagged Image File Format. This popular digital format uses lossless compression.

tripod
A three-legged stand that stabilizes the camera and eliminates camera shake caused by body movement or vibration. Tripods are usually adjustable for height and angle.

TTL
Through-the-Lens, i.e. TTL metering.

Tv
Time Value. See Shutter-Priority mode.

USB

Universal Serial Bus. This interface standard allows outlying accessories to be plugged and unplugged from the computer while it is turned on. USB 2.0 enables high-speed data transfer.

vignetting

A reduction in light at the edge of an image due to use of a filter or an inappropriate lens hood for the particular lens.

viewfinder screen

The ground glass surface on which you view your image.

wide-angle lens

A lens that produces a greater angle of view than you would see with your eyes, often causing the image to appear stretched. See also, short lens.

Wi-Fi

Wireless Fidelity, a technology that allows for wireless networking between one Wi-Fi compatible product and another.

zoom lens

A lens that can be adjusted to cover a wide range of focal lengths.

Index